IMAGES
of America

CHICAGO'S SWEET CANDY HISTORY

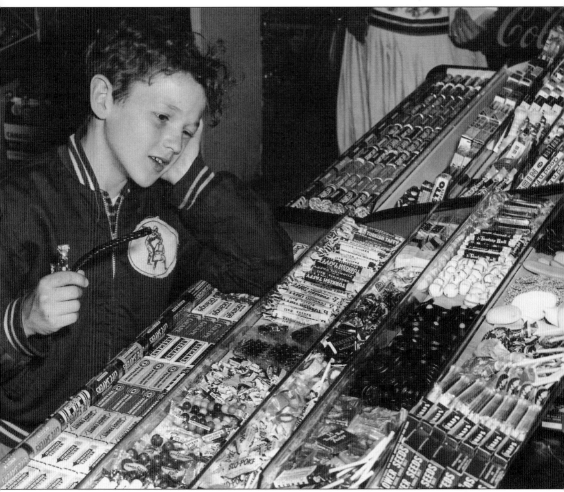

Happily overwhelmed by the choices, 11-year-old Larry Shearer could not make up his mind in front of a case of penny candy at a store on Kedzie Street in 1965. Among the local choices in front of him are Wrigley's gum, Leaf Sixlets and Fivesomes, Holloway's Slo Pokes, and Snaps from the American Licorice Company. (Author's collection.)

IMAGES
of America

CHICAGO'S SWEET CANDY HISTORY

Leslie Goddard

With best wishes,
Leslie Goddard

ARCADIA
PUBLISHING

Published by Arcadia Publishing
Charleston, South Carolina

Printed in the United States of America

Library of Congress Control Number: 2012933454

For all general information, please contact Arcadia Publishing:
Telephone 843-853-2070
Fax 843-853-0044
E-mail sales@arcadiapublishing.com
For customer service and orders:
Toll-Free 1-888-313-2665

Visit us on the Internet at www.arcadiapublishing.com

*To Granny, who shared my love for candy and always
bought a box of Fannie May candy for Christmas Eve*

CONTENTS

ACKNOWLEDGMENTS

This project began with the discovery that three notable candymakers—Otto Schnering, George Williamson, and Milton Holloway—once lived in Evanston (immediately north of Chicago), where I worked at the local history museum. It grew to encompass a story far richer than I ever imagined.

Unwrapping these stories was possible only with the selfless assistance of people who knew Chicago's candy companies. I am indebted to Ellen Gordon, Boz Bulovic, William Kelley, and Barry Yantis, who selflessly answered questions, shared memories, and corrected inaccuracies. David Dattalo, Mary Lou Wehrli, Michael Lahey, Terese Lang McDonald, Ron Toth, Tom Burke, and Amy Hansen shared precious photographs and stories. Tomi Holt at Jelly Belly, Katelin Lindley at World's Finest Chocolate, Mary Wills at Tootsie Roll, and Stacey Kidd at Blommer helped locate images from company archives. Kay Peterson and Shannon Perich at the Smithsonian Institution, Laura McLemore at Louisiana State University Shreveport, and many talented staffers at the Chicago History Museum assisted me with their valuable collections. Private collectors such as Darlene Lacey and Richard Saunders have my gratitude for preserving candy ephemera that might otherwise have disappeared.

Chris Metcalf, Jeff Ruetsche, and Amy Perryman of Arcadia Publishing recognized the book's potential in this research and provided expert guidance and inestimable advice.

My mother, Carol Goddard, offered sharp-eyed editing assistance and patient support. Elizabeth Amann shared her photography skills, while other family members—Laura, Rob, Caroline, Annie, and Robbie Amann and Joe and Carol Z. Goddard—generously helped with sampling products, sharing advice, and listening to endless stories. My husband, Bruce Allardice, as always, was my rock, selflessly giving time for this project, no matter what was needed.

The history of Chicago candy encompasses hundreds of companies—approximately 130 establishments in 1951 alone—ranging from huge manufacturing companies to small one-shop operations. Inevitably, and sometimes heartbreakingly, not all stores and companies appear in these pages.

The history of Chicago candy contains some conflicting facts and dates, in regards to which I have done my best to ensure accuracy. Images sometimes surfaced for which no credit information could be determined. I am grateful for assistance in correcting errors. Where not otherwise indicated, images are from the author's collection.

INTRODUCTION

Snickers. Milk Duds. Cracker Jack. Lemonheads. Juicy Fruit. Butterfinger. Whoppers. Name your favorite candy and, if you are American, chances are good it came from Chicago. For decades, the city produced about a third of all candy manufactured in the United States. At its peak, the Chicago candy industry boasted more than 100 companies employing some 25,000 Chicagoans.

Some of the biggest players in the industry called Chicago home: Curtiss, Brach, Tootsie Roll, Leaf, and Mars. So did smaller, family-based companies with devoted followings, such as fund-raising specialist World's Finest Chocolate and the Ferrara Pan Candy Company, maker of Lemonheads and Atomic FireBalls. Chicago began calling itself the "Candy Capital of America" around the start of the 20th century.

The history of Chicago candymaking is as old as the city itself. Chicago was incorporated as a city in 1837 and got its first candy business the same year, when John Muhr opened a shop on South Water Street near Wells Street. Muhr most likely sold locally in a city that was then little more than a frontier trading post, but two years later, the city had three candymakers. By 1870, it had 17.

In many ways, Chicago was an ideal location for a candy manufacturer. The city emerged as a railroad nexus as early as the 1850s, and its location in the core of America's agricultural heartland made it a natural crossroads for fresh ingredients. The industrializing cities of the Northeast and the farms and frontier settlements of the West met each other—literally—in Chicago. The city's period of greatest growth occurred at precisely the right time to take advantage of new advances in railroad and other transportation technology. The city's extensive railroad systems made national distribution a snap, and the commodities markets offered many raw ingredients at rock-bottom prices. Chicago confectioners found they could easily obtain fresh milk from nearby Wisconsin, corn starch and corn syrup from Illinois and Iowa, sugar beets from Michigan, and other essential agricultural ingredients from suppliers across the country and abroad.

These advantages remained for decades. Tootsie Roll, whose famous, largely unchanged recipe dates back to 1896, moved its production (and later its headquarters) from New Jersey to Chicago's southwest side in the late 1960s to take advantage of the central location and strong transportation networks that facilitated both distribution and production.

Ned Mitchell, then president of Brach's, cited agricultural proximity, rail connections, and efficient trucking for *Chicago* magazine in 1978 (as cited by Cecil Adams of Straight Dope Chicago): "The [Brach's] plant uses four to five railroad cars of sugar and three to four tank cars of corn syrup a day. Corn syrup is a basic ingredient of all candy and is traditionally priced F.O.B. [Free on Board or Freight on Board] Chicago. This is why we're a confectionery center . . . we have our own Belt Line rail connection here and wonderful trucking. That's something to consider in rush period, when we have tons of raw materials coming in and two million pounds of candy a day going out."

Immigration also played a role in Chicago's candy growth. The city's period of most rapid growth coincided almost exactly with mass European immigration to the United States, and

many immigrants made their way to Chicago. The city was already half foreign born in 1860; by 1890, seventy-nine percent of Chicagoans were born abroad (mostly in Europe) or were children of immigrants. Consider the names of Chicago's powerful candymakers: Otto Schnering, Salvatore Ferrara, Gustav Goelitz, Andrew Kanelos, Ferdinand and Gustav Bunte, Emil J. Brach, and so on. Many of these immigrants came to Chicago already armed with candymaking expertise. They opened businesses that initially catered to other immigrants with nostalgic yearnings for the sweet tastes of home.

Weather also played a part. Cool, crisp air is critical for making some particularly weather-fickle candies. A long winter extended the candymaking season in 19th-century Chicago, allowing candymakers to operate for up to seven months per year.

The growing concentration of candymakers in Chicago encouraged confectionery suppliers to settle in the city as well. Before long, the city had refiners of cane and beet sugar, makers of corn syrup and corn starch, corn and milk processors, makers of paper boxes, and manufacturers of flavor extracts. These suppliers, in turn, drew more candy manufacturers to Chicago, and the process cycled upwards. Henry Blommer Sr. and his brothers Aloysius and Bernard, for example, chose Chicago as the headquarters for their new Blommer Chocolate Company in 1939 because, as one family member later explained, "This is where our customers, the candymakers, were."

Before about 1870, most candy was made in small batches and sold generically as molasses kisses, sour balls, peppermints, or stick candy in flavors such as mint, lemon, clove, sassafras, wild cherry, and cinnamon. The Great Chicago Fire of 1871 destroyed many fledgling companies but occurred at precisely the ideal moment for the trade. The Industrial Revolution brought with it new machinery that could mix, mold, shape, coat, and package candies in bulk quantities. When they were rebuilt after the fire, many of Chicago's candy factories included the latest high-production equipment.

This new equipment helped confectioners to produce candy on a scale never before imaginable. New machinery for manufacturing candy, combined with the growth of mass transportation, brought manufactured candy to towns and farms far removed from major cities. Manufacturing confectioners had been selling nonperishable hard candies around the country for decades, but by the turn of the 20th century, even perishable candies could be sold nationally. The number of wholesale and manufacturing confectioners in Chicago expanded to 65 by 1900.

Candy consumption soared at the turn of the century. Annual candy consumption in the United States had been 2.2 pounds per person in 1880. It reached 5.6 pounds by 1914 and hit 13.1 pounds in 1919.

Chicago candymakers proved masterful at stimulating this mass market and promoting sales to match the new capacity for mass production. Initially, manufacturers focused on developing branded candies with unique appeal. One of the first branded confections was a molasses popcorn-and-peanut treat with no name until a salesman declared it "a crackerjack." Frederick and Louis Rueckheim, creators of Cracker Jack, invented or perfected a number of marketing ideas, including production techniques that kept their popcorn treat from sticking together and a triple-sealed package that ensured crispy freshness. They added the slogan "the more you eat, the more you want"; a friendly sailor boy mascot with a black-and-white dog; and, most famously, small prizes slipped into each box.

In Minnesota, small-time candymaker Frank Mars, seeking a candy bar that tasted like the trendy new malted milk shake, introduced the Milky Way in 1923, launching an empire that is now one of the world's largest privately held companies. Skyrocketing demand for Milky Way enabled Mars to open a new factory on Chicago's Far West Side in 1929. In addition to developing highly appealing candy combinations, Mars installed high-tech equipment that made his factory extremely efficient.

If railroad transportation let confectioners expand the market for their candies geographically, marketing let them expand their market culturally. Companies such as the Curtiss Candy Company and the Williamson Candy Company cast their advertising nets widely, educating rural and urban citizens alike about the freshness, reliability, and modernism of their branded candies. For many

Americans across the nation, buying modern candy from modern makers meant participating in the modern age.

George Williamson went to great lengths to establish and maintain the reputation of his Oh Henry! candy bar. To convince people to spend a dime instead of the usual nickel for Oh Henry! when it debuted in 1920, he launched an advertising blitz that included newspaper and magazine advertisements, streetcar signs, and roadside billboards. Available only as a pre-packaged item, Oh Henry! worked via a direct relationship between consumer and manufacturer. Buyers learned to look for the Oh Henry! name rather than simply purchasing whatever bulk candy the local grocer had in stock. To simplify name recognition, Williamson gave his candy bar a memorably whimsical name. It worked. Within three years, Oh Henry! was America's top-selling candy bar.

Chicago candy manufacturers spent enormous sums on advertising, and some of the most innovative ideas in candy marketing came from Chicago. William Wrigley Jr. mailed free sticks of his gum to all 1.5 million homes listed in the 1915 United States telephone books (on the hunch that anyone who could afford a telephone could afford gum). Once, he created a "mile-long" sign consisting of 117 linked billboards lining the tracks of a railroad between Atlantic City and Trenton, New Jersey. For many years, Wrigley made just three gums—Juicy Fruit, Spearmint, and Doublemint—but his groundbreaking advertisements made them top sellers nationwide. "Tell 'Em Quick and Tell 'Em Often" was his famous catchphrase.

Otto Schnering plastered the name of his Baby Ruth candy bar on everything from matchbook covers to airplanes. He was also a stickler for quality and freshness. The *Wall Street Journal* took notice when the Curtiss Candy Company ordered 200 refrigerated boxcars in 1928: "For the first time in history, it is claimed, a candy manufacturer is building refrigerator cars for its exclusive use. . . . The day the bars are made some 3,500,000 of them are shipped." It was not bad for a man who started as a piano salesman and cooked up his first candies in a 20-by-30-foot storeroom on Clark Street with one stove and a five-gallon kettle.

E.J. Brach and Sons invested early in mechanized production and developed creative merchandising strategies to match its manufacturing capability. Brach's signature Pick-a-Mix stands were introduced in 1958. These self-serve displays, adapted from the barrels seen in general stores, allowed customers to scoop their own assortments of candy priced by the pound. The enormous Brach factory on Chicago's West Side would eventually become the world's largest candymaking operation under one roof.

Not all candymakers aimed for a national audience. Marshall Field & Company's famed Frango Mints were available only in its stores, giving the candies an exclusivity that helped to cement its status as a Chicago icon. In 1920, H. Teller Archibald started Fannie May, a retail candy chain that capitalized on shoppers' nostalgia for kitchen-fresh, homemade candies. Archibald's Fannie May stores were located in convenient, well-trafficked sites. When oil prices soared in the 1970s, Fannie May bought shuttered gasoline stations and converted them to parking-friendly, freestanding candy shops.

Urban manufacturing, railroads, advertising, and innovative new marketing approaches came together, creating a candy industry in Chicago that was second to none. By 1963, Chicago's candy output was about double that of New York City, the country's second largest candymaking center.

Chicagoans could purchase candy in newsstands, grocery stores, department stores, dime stores, and freestanding retail stores representing local and national chains. The city's landscape was dotted with candy stores, including Mrs. Snyder's, Mrs. Steven's, Andes, DeMet's, Dutch Mill, Fannie May, Cunis, Cupid, Dove, and Joy.

As the 20th century progressed, however, Chicago's candy dominance began to fade. A wave of corporate mergers swept the industry. Leaf Brands, the company created by Chicagoan Sol S. Leaf that became famous for Whoppers malted milk balls and Rain-Blo bubble gum, fell victim to a sequence of mergers, acquisitions, and divisions. The Hershey Company eventually acquired most of the company's North American candy brands, ending Leaf's existence as a separate operating unit in the United States. The Holloway Candy Company, which Milton J. Holloway

started in 1920 with just $500 in secondhand machinery, sold Milk Duds and Slo Pokes nationally for much of the century. Its individual brands went through a sequence of ownership changes. As a result, Milk Duds and Whoppers are now made by Hershey; Slo Pokes and Black Cows are made by the Warrell Corporation's Classic Caramel Company; and Rain-Blo is made by Farley's and Sathers.

Chicago's inherent advantages simply did not meant as much as they had decades earlier. Rail transportation and weather no longer played the defining roles they had in the 19th century. American candymakers now had to grapple with sugar subsidies that kept the price of domestic sugar higher than on the world market and tight import quotas that made it difficult to import less-expensive foreign sugar.

The end of the 20th century included a string of closings that brought tears to the eyes of Chicago's candy lovers. Frango candies, which had been made on the 13th floor of Marshall Field & Company's flagship department store on State Street for decades, moved out of state in 1999. Fannie May went bankrupt in 2004, and production shifted out of state. Peerless Confectionery, maker of hard candies in Chicago since 1924, closed down operations in 2007, leaving devotees mourning the loss of its root beer barrels and peppermints. Giants Brach and Wrigley shuttered their Chicago factories in the mid-2000s. In 2004, the *Chicago Tribune* reported that Chicago had around 7,000 jobs in the candy industry, down almost 50 percent from just 10 years earlier.

However, Chicago is still sweet on candy. You still smell chocolate in the air here. The metropolitan area remains home to a number of famous, long-standing companies, including Tootsie Roll, Ferrara Pan Candy Company, Blommer Chocolate Company, American Licorice Company, Willy Wonka Candy Company, and World's Finest Chocolate. Nestlé and Mars both operate candy factories here. Wrigley merged with Mars in 2008 and sold the landmark Wrigley building in 2011, but its headquarters remains in Chicago. Many Fannie May retail shops reopened, and Macy's earned goodwill when it returned some Frango candy production to Chicago in 2008.

Small family-owned and -operated candy shops such as Margie's Candies, Cupid Candies, and the Fudge Shop continue to lure fans of homemade candy specialties. With the emergence of new boutique companies and innovative retro candy outlets, many predict Chicago will remain a sweet spot for candy lovers for decades to come.

One

CREATING AN INDUSTRY
BEGINNINGS THROUGH 1880s

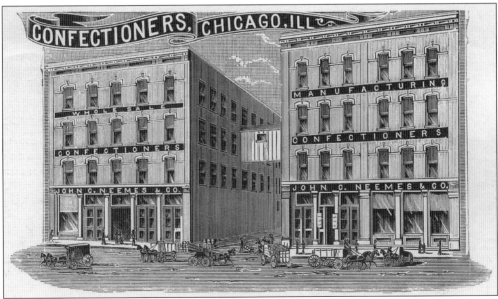

While modest by today's standards, John C. Neemes's candy factory was immense for 1887, spanning two buildings at 28–34 North Michigan Avenue. The firm, established under a different name in 1858, could claim to be one of the city's oldest. After suffering destruction in the Great Chicago Fire of 1871, the reformed firm did business nationwide, with transactions totaling more than $500,000 annually. Family legend holds that the Neemes firm invented chocolate-covered raisins.

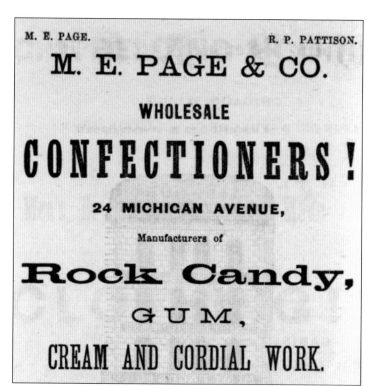

M. E. PAGE. R. P. PATTISON.

M. E. PAGE & CO.

WHOLESALE

CONFECTIONERS !

24 MICHIGAN AVENUE,

Manufacturers of

Rock Candy,

GUM,

CREAM AND CORDIAL WORK.

Milton E. Page & Co., considered "the leading confectionery house in the West" in 1869, made more than 400 varieties of candy. As this advertisement shows, rock candy was a top seller, but the company also handled fine candies, such as nougats and almond paste. Page claimed strong Chicago roots; the son of one of Chicago's earliest settlers, he entered the confectionery trade in 1861 and within eight years occupied an entire four-story building.

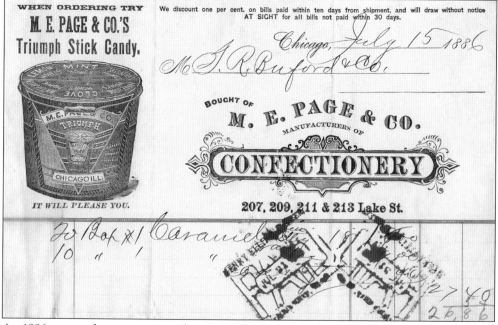

An 1886 invoice shows a container listing Page's stick candy flavors: mint, sassafras, horehound, clove, and lemon. Inexpensive and nonperishable, stick candy dominated the output of early confectioners, accounting for up to half the stock of sales agents in the 1880s. Page sold to retailers as far south as Texas and as far west as California. In 1875, the firm filled an order for 34,000 pounds of candy, shipping it to San Francisco within 30 hours.

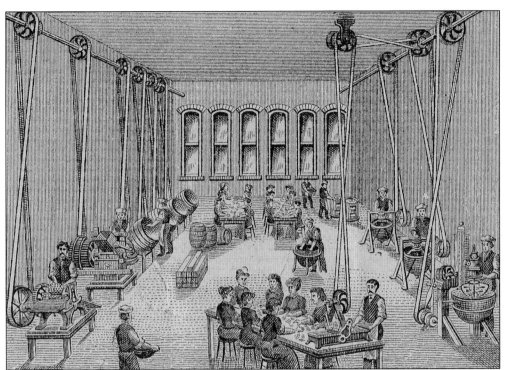

Belt-driven modern machinery lined the walls of Martin Dawson's Kinzie Street factory. Pictured on an 1887 invoice, this image aimed to impress customers with the firm's state-of-the-art production capability. Note the gender division of labor: Men work the machines—mixing, panning, and forming candies— while women wrap candies. The Irish-born Dawson immigrated to Chicago in 1852, joining the staff of one of Chicago's earliest confectioneries as a boy.

Charles F. Gunther loomed large in Chicago confectionery for some 40 years, operating what was reportedly America's largest candy shop in the 1890s. Born in Germany, he worked a number of jobs, including salesman for a wholesale candy confectioner, before opening his own candy shop in Chicago in 1868. (Chicago History Museum, ICHi-24186.)

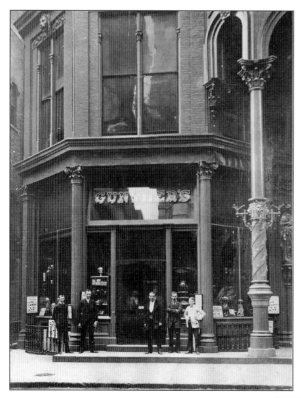

The Great Chicago Fire of 1871 destroyed Charles Gunther's business, but he quickly recovered, reopening in this corner of the McVicker's Theater building on Madison Street near State Street. Candy shops frequently flanked theaters, which not only provided a ready market but also a regular stream of passersby. In 1886, with business flourishing, he moved into a seven-story wholesale factory and retail store at 212 South State Street. (Chicago History Museum, ICHi-65048.)

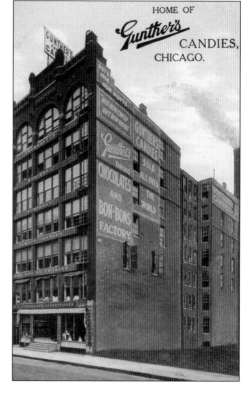

Slogans and signs decorated the walls and roof of Gunther's seven-story building, reminding passersby that his candies "cannot be equaled" and were "sold all over the world." Inside, two entire floors displayed Charles Gunther's eclectic collection of rare paintings, historic autographs, and historical curiosities purchased with his confectionery fortune. Many of these priceless relics later formed the nucleus of the Chicago Historical Society's renowned Civil War collection.

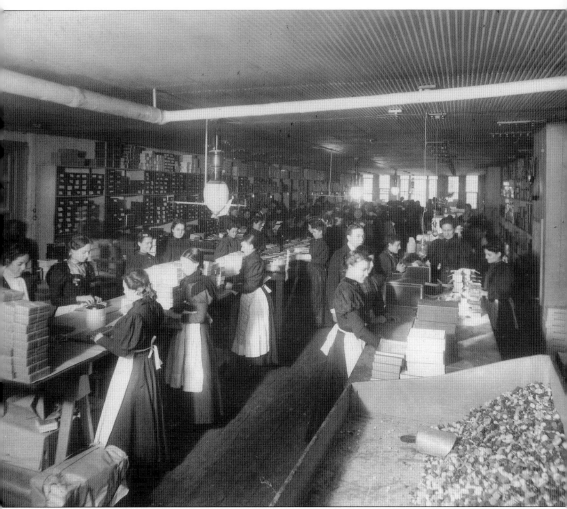

Long tables stretched down the workroom where Gunther employees wrapped and packaged what advertisements touted as "the best candy in the world." "O, delicious! Ten thousand times delicious!" raved "Mrs. L" in a (probably contrived) 1875 diary entry about these candies. Gunther sold hard candies, chocolates, and bonbons, but was especially known for his caramels. Some contemporary newspapers claimed Gunther invented caramels. He did not, but he did help popularize them, not only in Chicago but across the country. Below this third-floor workroom, retail trade occupied the building's first and second floors. The basement held equipment for making ice cream and soda water. (Chicago History Museum/J.W. Taylor, ICHi-20412.)

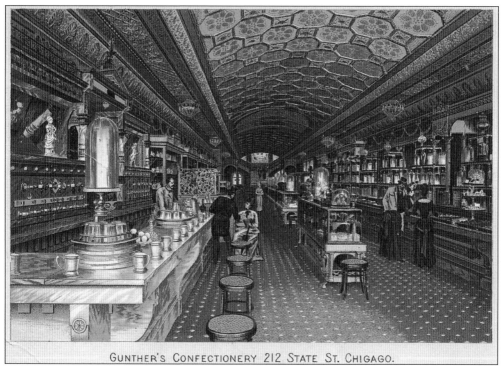

GUNTHER'S CONFECTIONERY 212 STATE ST. CHIGAGO.

"[N]ever before in this country has such a combination of materials been brought together in such a grand harmony of design," declared the *Chicago Daily Tribune* about the luxurious interior of Gunther's store. It featured a marble floor, gold fixtures, and a custom-built soda fountain (left), said to be one of the largest ever created. Above the rose-colored marble staircase (rear) sat a window of hand-cut stained glass. Gunther's customers included members of the Chicago elite, such as society doyenne Bertha Honoré Palmer.

German-born Gustav Bunte learned candymaking in Philadelphia before teaming up with his brother Ferdinand and friend Charles A. Spoehr to open a retail and wholesale candy company in a little two-story frame building at 416 State Street in 1876. The company, later named Bunte Brothers, grew rapidly, employing 1,200 people by 1918. A number of other candymakers got their start with Bunte, including Emil Brach and George Williamson (of Oh Henry! fame). (Barry Yantis.)

Two

Immigrants, Inventors, and Entrepreneurs
1890s–1900s

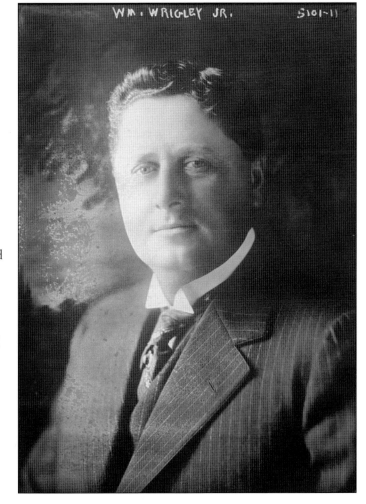

William Wrigley Jr. arrived in Chicago in 1891 with just $32 in his pocket. His father was a soap manufacturer, so Wrigley began selling soap. As an extra incentive, he offered store owners premiums to carry his soap. When packages of chewing gum proved especially popular, he bought the gum company. Before long, he was offering store owners everything from scales to coffee grinders to carry his gum.

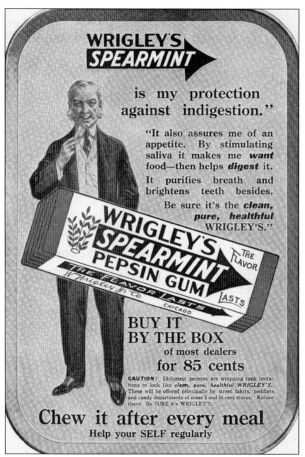

Note the emphasis on the health value of chewing gum in this 1914 Wrigley advertisement: it stimulates appetite, helps digestion (pepsin is a stomach enzyme), and cleans teeth. These were key selling points for buyers who found gum-chewing unseemly. Wrigley plastered advertisements for his gum on trolley signs and billboards, in magazines, and anywhere that might draw attention.

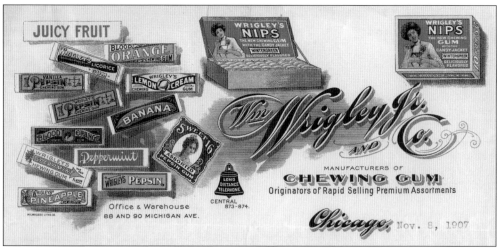

Engravings on the company's letterhead offer a snapshot of Wrigley's various gum flavors in 1907, including banana, vanilla, lemon cream, blood orange, and pineapple. Sweet 16 was one of Wrigley's original gums, while Juicy Fruit and Spearmint debuted within months of each other in 1893. Doublemint did not appear until 1914. (Warshaw Collection of Business Americana—Chewing Gum, Archives Center, National Museum of American History, Smithsonian Institution.)

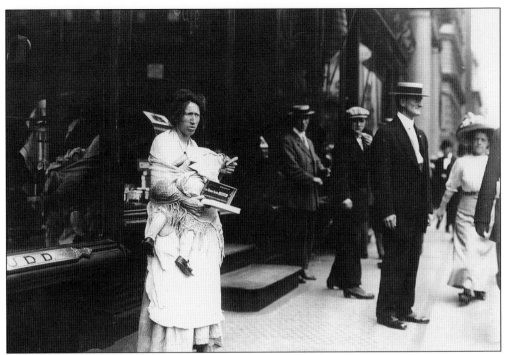

A peddler sells packs of Wrigley's Spearmint gum on the streets of New York City around 1909. Street peddlers who worked the heavily traveled thoroughfares of major cities often sold candy, which was easy to transport and sell. Initially, many peddlers sold homemade candy, but when fears of cheap, adulterated candy arose, many peddlers switched to more trusted commercial products. (Library of Congress, Prints and Photographs Division, LC-B2-2294-1.)

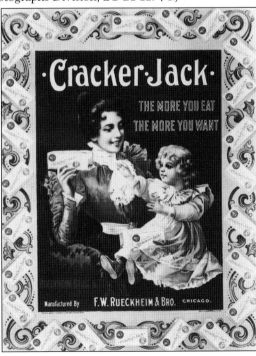

This illustration captures the earliest Cracker Jack box design. Two German brothers—Frederick and Louis Rueckheim—invented the molasses-glazed popcorn-and-nut snack, an early version of which received its first widespread exposure at Chicago's 1893 World's Columbian Exposition. The Rueckheims somehow devised a way to keep their sweet-and-salty treat from clumping into a sticky mess. In 1896, an admiring salesman declared, "That's a crackerjack!" (meaning something first-rate), and the treat received its celebrated name. (Ron Toth Jr. Collection and Time Passages Nostalgia Company.)

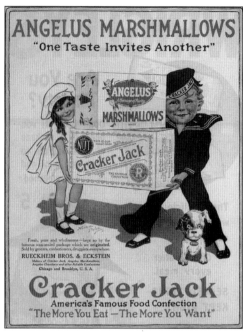

The reputation of the Rueckheim brothers' two standout products—Cracker Jack and Angelus Marshmallows—rested on their freshness. In the struggle to keep Cracker Jack fresh, a friend of the Rueckheims, Henry G. Eckstein, developed a wax-sealed, moisture-proof package that enclosed the snack in air-tight layers, ensuring crispness and cleanliness. Consumer sales soared. In gratitude, the firm was renamed Rueckheim Brothers and Eckstein in 1903.

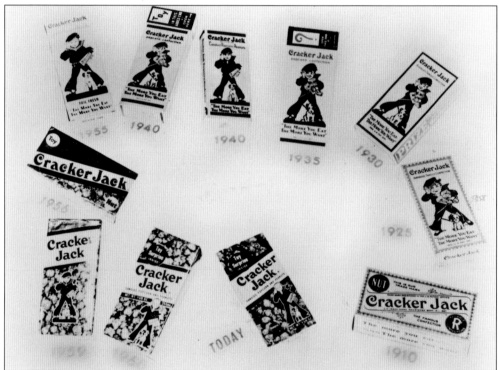

Over the decades, the friendly mascots—Sailor Jack and his dog, Bingo—have smiled at consumers from the front of Cracker Jack boxes. The sailor boy was reportedly modeled on Frederick Rueckheim's grandson Robert, who died of pneumonia shortly after the character appeared in 1918. In 1922, the year of its 50th anniversary, the company honored its most popular product by changing its name to the Cracker Jack Company.

With its crispy freshness, Cracker Jack made an ideal treat for beaches and outdoor picnics, as shown in this photograph from Coney Island, New York. The Rueckheims promoted their confection nationally, devising the famous slogan "the more you eat, the more you want." In 1937, they declared it "America's oldest, best known and most popular confection." (Ron Toth Jr. Collection and Time Passages Nostalgia Company.)

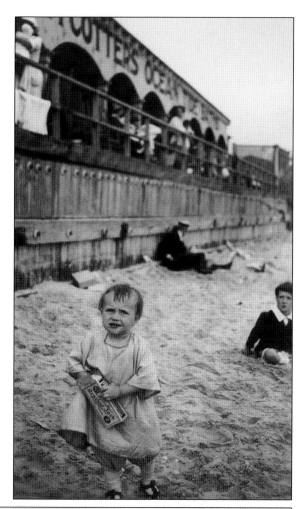

Two expansive Johnny Wall concession tents flanked the ticket truck at a Gorman Brothers Circus performance in Long Island, New York, in 1934. Concessioners often sold Cracker Jack along with popcorn bricks and bagged peanuts at circuses, theaters, parks, picnics, and carnivals, making the familiar box an indelible indicator of early-20th-century amusements. Note the geometrically stacked Cracker Jack boxes on the tables. (Ron Toth Jr. Collection and Time Passages Nostalgia Company.)

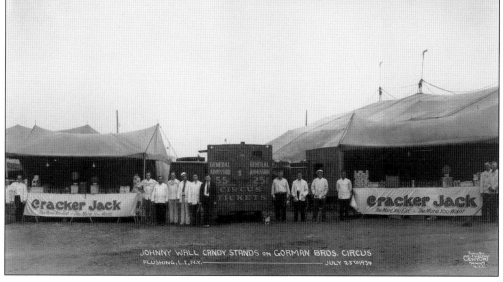

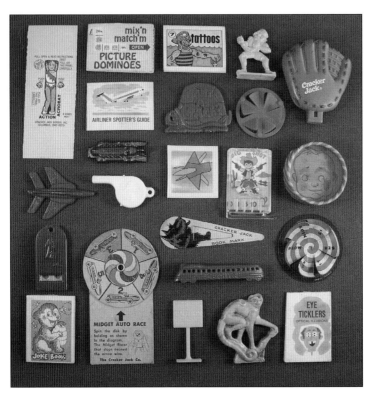

In 1912, Cracker Jack began enclosing prizes in every box, launching a promotional juggernaut. As of 2010, more than 23 billion toys, trinkets, and other surprises have been given out. Many reflect the era in which they were introduced, such as a 1930s Zephyr train locomotive (center, near the bottom) and a 1970s airliner spotter's guide (center, upper left). Others, such as whistles, joke books, and spinners, have remained popular through the years. The most sought-after vintage Cracker Jack prizes fetch up to $7,000.

Other candymakers, including Chicago's National Candy Company, sold popcorn packaged with prizes. In fact, the practice of selling candies plus a prize, novelty, or gift dates back as far as the 1870s. Companies such as Dowst Brothers of Chicago (later known for Tootsietoys) offered entire lines of novelties suitable for tucking into packages of penny candies or giving away as premiums. Prizes ranged from paltry tokens to watches and silver coins.

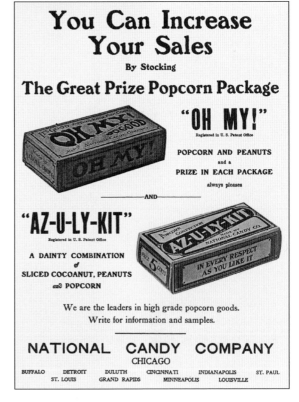

No one could miss the colossal box atop the Cracker Jack plant at Harrison and Peoria Streets. "No human hands touch Cracker Jack in the making," the company proclaimed, noting its battery of automatic poppers, steam-jacketed copper cooking kettles, and automatic machines for pouring Cracker Jack into packages and sealing them. Automation and widespread advertising permitted retailers to sell Cracker Jack profitably for 5¢. (Chicago History Museum/Hedrich-Blessing, William S. Engdahl, HB-21557.)

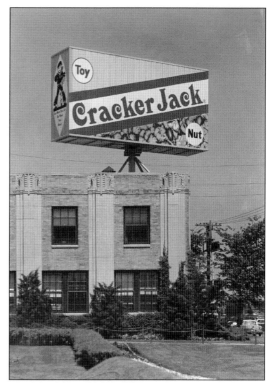

This 1917 photograph captures the delivery truck of "H.D. Swisher, Wholesale Confections" from Danville, Illinois. Swisher was a "jobber," or wholesaler, who dealt in small lots of goods ("jobs") and acted as an agent or middleman. Jobbers typically purchased candy from manufacturers and resold it to shops, turning their delivery trucks into mobile billboards. (Ron Toth Jr. Collection and Time Passages Nostalgia Company.)

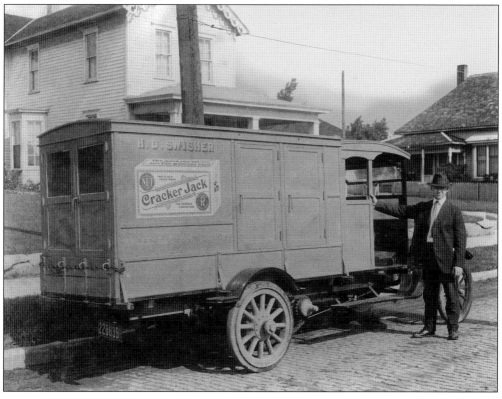

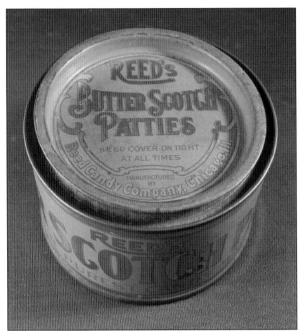

Few confectioners have been as closely associated with a single flavor as Reed Candy Company, long synonymous with butterscotch. Begun in 1896 as the Eugene O. Reed Company, the firm initially gained fame for its "patties" made with butterscotch as well as horehound and chocolate flavors. Reed's butterscotch hard candy rolls debuted in 1931, later followed by other flavors, including cinnamon and root beer. Reed's factory at Lakewood Avenue and Fletcher Street closed around 1984.

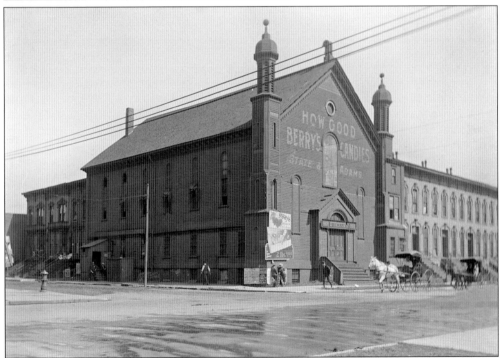

Berry's Confectionery manufactured candy in this former church building at Washington Boulevard and Sangamon Street. A sign proclaimed "Berry's Candy Must be Good—Made in a Church." Born in Manchester, England, John Berry had three candy shops within 10 years of opening his first store. In 1903, Chicago's self-proclaimed "Most Popular Candy Store" claimed a devoted following. The State Street store once drew 11,061 customers in a single day. (Chicago History Museum/Chicago Daily News negatives collection, DN-0001284.)

Genial businessman Emil J. Brach scraped together $1,000 to open his Palace of Sweets at North Avenue and Towne Street in 1904. There, the German immigrant worked with his sons Edwin and Frank in a one-kettle kitchen. He gradually added production-boosting equipment, enabling him to sell candy for 20¢ per pound—well below the typical retail price of 50¢ to 60¢. By 1911, Brach's production topped 50,000 pounds per week.

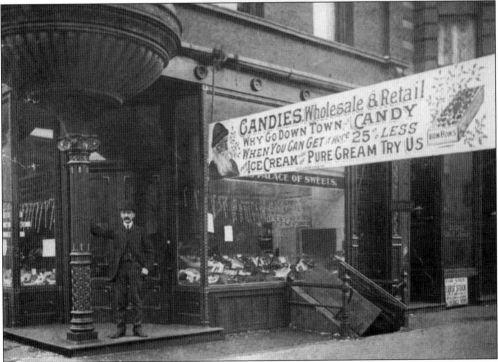

Emil Brach (posing at the door of his first modest store) must have known how propitious his timing was. New machinery and decreasing sugar prices were enabling confectioners to diversify. While stick candy had dominated just 30 years earlier, candymakers now offered everything from caramels and nougats to dipped nuts. Chicago's exploding population created a huge retail market for these goods. Brach was soon selling to virtually all of the large department stores in Chicago.

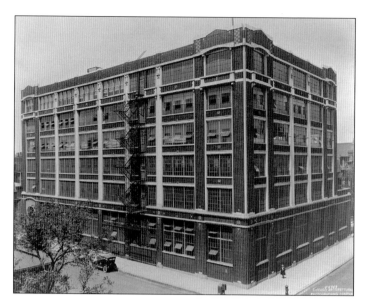

E.J. Brach and Sons expanded so rapidly that by 1923 they had four factory buildings and were outgrowing them all. With production stretched, they built a new factory on Chicago's West Side for $5 million. The new factory, located at 4656 West Kinzie Street, consolidated production of the company's 127 different kinds of candy, with a capacity of 2,225,000 pounds weekly. (Chicago History Museum/Hedrich-Blessing, HB-13239-B.)

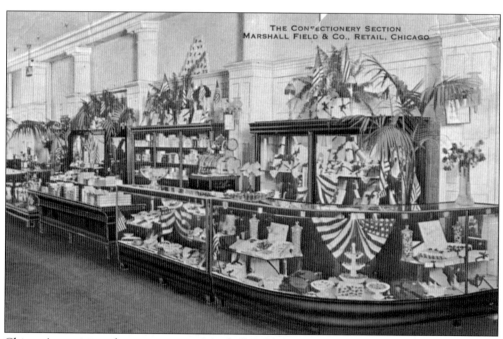

Chicago's prestigious department store, Marshall Field & Company, boasted a lavish confectionery department in its new 1907 building. Department stores, with their roots in dry goods merchandising, had been slow to add candy. However, as *Confectioners Gazette* reminded its readers in 1914, an attractive candy counter could lure a department store's female clientele to buy high-end candies on impulse: "Candy is woman's least expensive luxury and hence indulged in most."

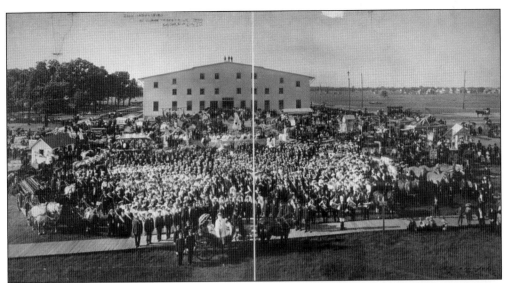

Throngs of workers assembled in 1904 outside the spacious complex that housed the candy, soap, and lace factories of Zion, Illinois. Controversial religious leader John Alexander Dowie set up the industrial complex as part of his utopian community. Its candy company, known as the Candy Division of Zion Industries, made a popular fig-based candy called the Fig Pie. Although the town was eventually reorganized and the church lost its control, the candy company continued operating until 1961.

Unscrupulous confectioners of the day were known to coat hard candies with varnish, mix in chalk or clay to whiten candies, or color goods with toxic dyes. The National Confectioners Association, armed with "good laws" and cooperation, unleashed a war against adulterated candy. Founded in Chicago in 1884 by representatives of 69 candy manufacturers, the NCA joined physicians and journalists in making "purity" its battle cry.

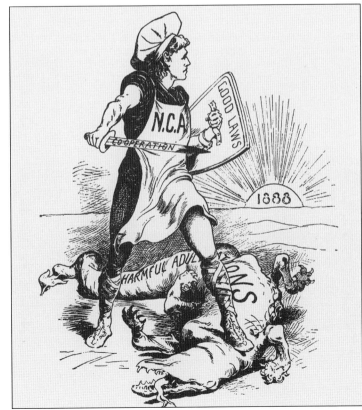

CANDY RECIPES

Compiled by the
HOME SERVICE DEPARTMENT
Eva Hawkins Shanks, *Director*

PUBLIC SERVICE COMPANY
OF NORTHERN ILLINOIS

A sweet-faced girl graced the cover of this booklet of recipes for when, as author Eva Hawkins Shanks explained, "a group of young folks say 'Let's go home and make some candy.'" Between the 1890s and 1910s, homemade candy was promoted as a safe alternative to adulterated commercial candy, and making candy was encouraged as wholesome home entertainment. Recipe booklets linked candymaking to the safe, feminine world of motherhood and caretaking.

Girls at elite eastern colleges sparked a rage for fudge-making that swept the country at the beginning of the 20th century. Although quick and cheap, fudge-making required skill and precision. Fudge soon became a favorite present for family members and close friends. Gifts of homemade candy were significant tokens of friendship and affection because they stood out from the generic, mass-produced candies available in stores.

Three

CANDY BOOM YEARS
1910s–1920s

The bewhiskered Gustav Goelitz (left) sat with his family for this early portrait. After emigrating from Germany, Goelitz and his brother Albert operated a candy shop in Belleville, Illinois, until economic upheavals in the 1890s forced them to sell their business. Gustav's sons picked up the sweet tradition. By 1912, the Goelitz Confectionery Company was turning away orders for lack of production capacity and began looking to North Chicago for a new site. (Jelly Belly Candy Company.)

Note the rumpled clothing on workers at the Goelitz factory in North Chicago in 1912. Cooking up as many as 50 batches of candy per day during the busy season of March through November was hot, sweaty work. Goelitz made peppermints, licorice, and chocolate but specialized in chicken feed (now known as candy corn). Family members Arthur, Herman, and Armin Goelitz stand in the second row, from left to right, on the step. (Jelly Belly Candy Company.)

Goelitz workers mixed, cooked, molded, and packed the company's peppermints, licorice, and other candies. It took strength to unload deliveries of sugar and starch, lug candy syrup to the molding trays, and spread finished candy out to cure before packing it into barrels for shipping. Goelitz (later renamed the Jelly Belly Candy Company) is now headquartered in California but still operates a factory in North Chicago and a distribution center in nearby Pleasant Prairie, Wisconsin. (Jelly Belly Candy Company.)

A photographer covering a cold weather snap captured US diplomat Robert S. McCormick walking past the Original Allegretti Chocolate Crème shop at 300 South Michigan Avenue in 1914. A bewildering sequence of candy stores with "Allegretti" in their names, run by competing members of the Allegretti family, appeared on State, Wabash, Grand, Lake, and Randolph Streets in this era. (Chicago History Museum/Chicago Daily News negatives collection, DN-0063759.)

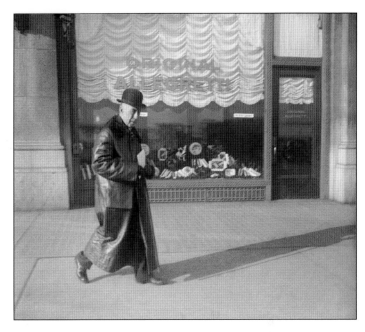

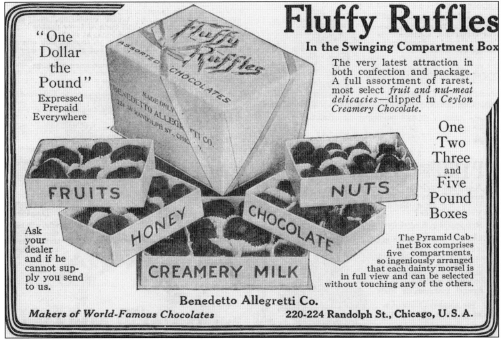

Fluffy Ruffles

In the Swinging Compartment Box

"One Dollar the Pound"

Expressed Prepaid Everywhere

The very latest attraction in both confection and package. A full assortment of rarest, most select *fruit and nut-meat delicacies*—dipped in *Ceylon Creamery Chocolate.*

One Two Three and Five Pound Boxes

FRUITS

NUTS

HONEY

CHOCOLATE

CREAMERY MILK

Ask your dealer and if he cannot supply you send to us.

The Pyramid Cabinet Box comprises five compartments, so ingeniously arranged that each dainty morsel is in full view and can be selected without touching any of the others.

Benedetto Allegretti Co.

Makers of World-Famous Chocolates 220-224 Randolph St., Chicago, U.S.A.

A box of Fluffy Ruffles from the Benedetto Allegretti Company came in a swinging box that pivoted open to reveal the contents, neatly divided by flavor. Elaborate packaging gave an aura of distinctiveness and exclusivity to chocolates sold as status goods. Candy choices, including the decision of where to buy one's candy and what type to buy, expressed the buyer's taste and class.

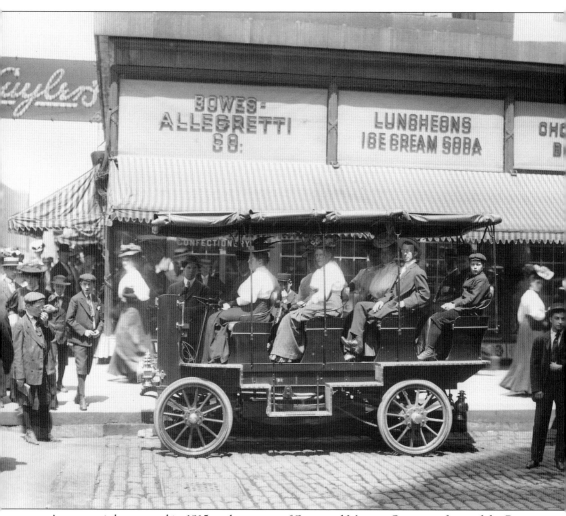

An open-air bus paused in 1915 at the corner of State and Monroe Streets in front of the Bowes-Allegretti shop, where shoppers could enjoy luncheons, ice cream sodas, and chocolates. Since candy stores were acceptable places for women to dine unescorted, many shops offered lunches as well as candy and ice cream. The Huyler's sign (upper left) indicates a New York–based candy store and restaurant located around the corner. Huyler's was among the national confectionery firms that opened stores in Chicago, especially in the downtown area. By 1930, Huyler's had four Chicago candy stores. (Library of Congress, Prints and Photographs Division, LC-D4-39414.)

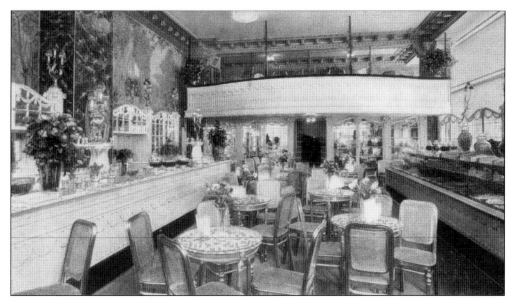

The interior of the Bowes-Allegretti shop, seen here around 1908, was swathed in Louis XIV decor, including gilded ceiling cornices and floral wall hangings. Like many candy shops of the era, this one featured a soda fountain. Soda fountains had become important social centers, often replacing taverns in the urban social fabric, especially as Prohibition took hold. The elegant decor was meant to appeal to the intended clientele: well-to-do women.

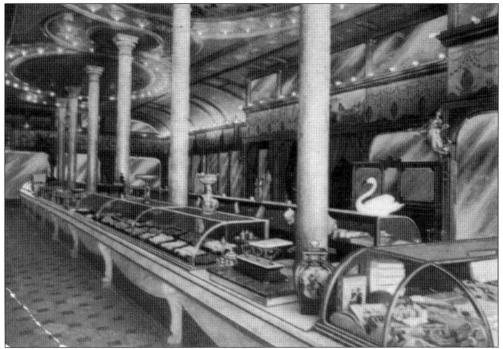

The interior of the elegant confectionery run by John Kranz at 126–132 State Street included bisque marble pillars and animated white swans. Like Bowes-Allegretti and other combination ice cream and candy shops at the turn of the 20th century, Kranz's featured graceful, refined interior decorations—a contrast to the heavy trim and dark wood paneling common in male saloons.

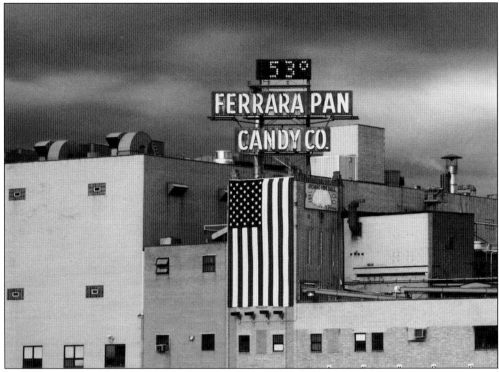

The Ferrara Pan Candy Company (pictured here in the 1990s) has been a longtime presence in Forest Park. The company's roots date to 1900, when Salvatore Ferrara emigrated from Italy, bringing along his expertise in making the candy-coated almonds known as confetti. Ferrara opened a retail bakery and confectionery that made panned candies in large rotating kettles. In 1919, Ferrara partnered with two brothers-in-law to begin manufacturing a variety of panned candies. (Mark Weissburg.)

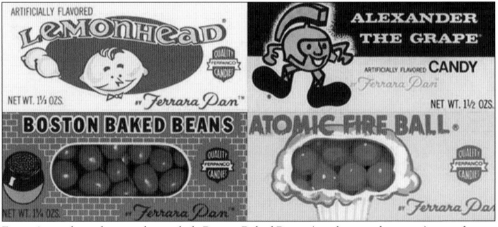

Ferrara's now-legendary candies include Boston Baked Beans (candy-coated peanuts), one of many candies whose names evoke other foods without actually tasting like those foods. Mouth-puckering Lemonheads were developed in 1962 using the same panning methods as the company's cinnamon Red Hots. Alexander the Grape was later retired, although today's Grapeheads continue the grape tradition. Atomic FireBalls, created in 1954, were among the earliest super-spicy candies. (candywrappermuseum.com.)

Sometime around 1905, Bunte Brothers pioneered the process of making hard candies with soft fillings. Its Diana "Stuft" Confections consisted of 21 varieties of hard candies filled with preserves, nuts, jams, or jellies. Bunte not only created the candy, but also built the machinery required to make the popular treats. They quickly became a favorite and helped position Bunte among the nation's top candymakers in the early 20th century.

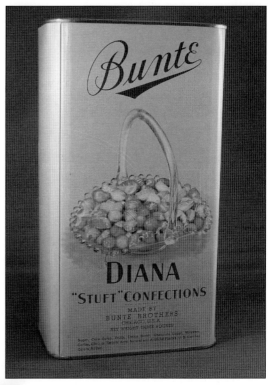

An early postcard for Bunte showed a beautiful young girl posed with candy, of which women were the primary recipients. The depiction of a lovely woman indulging her appetite carried sensual overtones in an era still steeped in Victorian restraint. This card, intended for a retail store owner, announced on the reverse side the imminent arrival of one of the company's traveling salesmen.

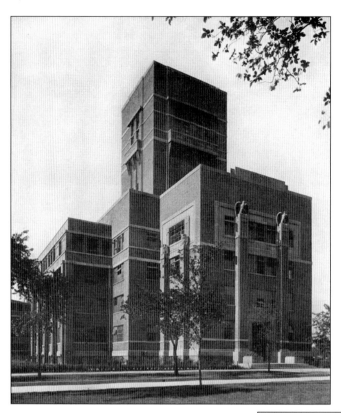

With capacity stretched to the limit, Bunte Brothers announced plans to build the country's most modern and efficient candy factory. The Prairie-style factory at 3301 West Franklin Boulevard was said to be the world's largest candy factory when it opened in 1921. It included rooftop handball courts, a restaurant for 2,000 people, and facilities for making 1,500 kinds of candies. The building was later retrofitted into a high school; it was demolished in 2008.

A group of Bunte Brothers employees, headed by Gilda Dentino, pose for a photograph in 1929. Since candy factories frequently drew employees from the surrounding neighborhoods, workers often came from similar ethnic or national backgrounds and shared bonds of friendship and culture. The neighborhood around the Bunte factory in the 1920s and 1930s included many Italian Americans and Jewish immigrants from Germany and Russia. (Dominic Candeloro.)

The combination tobacco-candy store dated to the 1880s, when tobacco manufacturers began inserting baseball cards into tobacco packages as both stiffeners and sales-boosting premiums. When children began hanging out near tobacco shops, hoping to nab discarded cards, confectioners began putting similar cards in their packages and an enduring retail connection was born. (Chicago History Museum/Chicago Daily News negatives collection, DN-0064856.)

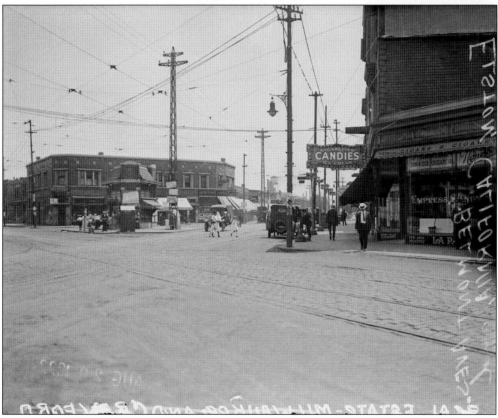

The Empress Candy Shop enjoyed an ideal location at the bustling intersection of Elston and California Avenues, where streetcar and pedestrian traffic accumulated in this 1922 image. Before the rise of retail grocery chains and mass merchandisers, candy and tobacco stores in both small towns and large cities were essential retailers for major confectionery manufacturers. (Chicago History Museum/Chicago Daily News negatives collection, DN-0074799.)

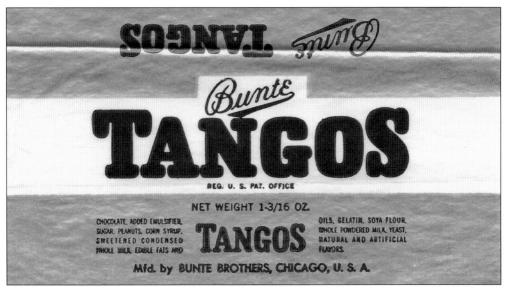

Other than the Goo-Goo Cluster, few combination candy bars existed when Bunte introduced its marshmallow-maple Tangos in 1914 (a 1950s wrapper is shown here). Named for the elegant, sensual music and dance, Tangos sold well for decades before being retired in the 1960s. Barry Yantis, of the Chase Candy Company, recalled, "I remember eating them as they came off the cooling tunnel—to this day the best candy bar I ever ate!" (Barry Yantis.)

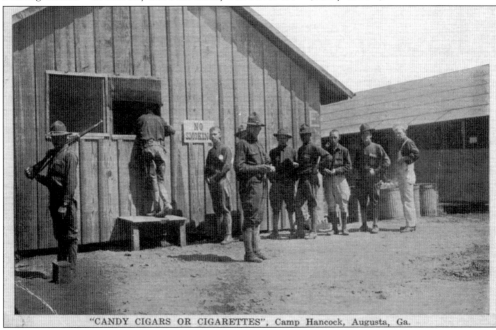

"CANDY CIGARS OR CIGARETTES", Camp Hancock, Augusta, Ga.

Soldiers at Camp Hancock in Georgia lined up to buy candy, cigars, and cigarettes from the canteen. Soldiers consumed huge quantities of candy during World War I, both in rations and through canteens, significantly impacting the legitimacy of candy-eating in the civilian world. Whereas candy had previously been associated mostly with women (boxed chocolates) and children (penny candies), soldiers made candy consumption acceptable and customary for men. Postwar candy sales soared.

Tangos' popularity among World War I soldiers boosted their popularity among civilians, and Bunte was quick to promote an image of their candy as the food that had nourished and sustained the soldiers. In the past, confectionery advertisements had pictured candy as a luxury and an indulgence. Now, they positioned candy as a quick-energy food and a dietary staple.

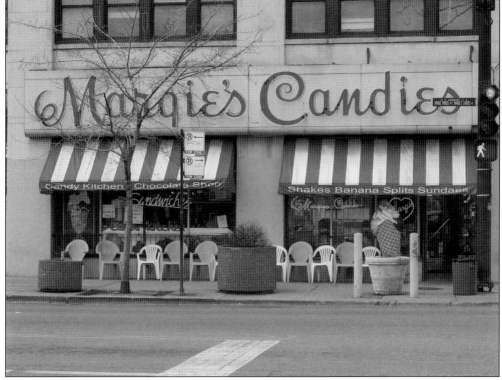

Margie's Candies has been a Chicago legend for nearly 100 years. In 1921, Greek immigrant Peter George Poulos opened the original sweet shop on Western Avenue, pictured here in 2012. His son George married a woman named Margie and renamed the shop for her. After her husband's death, Margie ran the store herself for some 40 years. Al Capone reportedly bought chocolates here, and the Beatles stopped by after playing Comiskey Park in 1965. (Elizabeth Amann.)

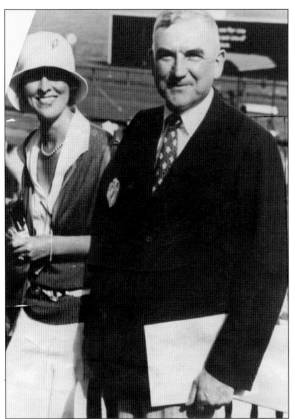

H. Teller Archibald (right) worked as a newspaper reporter and real estate entrepreneur before opening his first Fannie May candy store in 1920. He grew his candy business aggressively. By 1925, he had 23 candy stores. By 1935, he had 47 stores in Illinois, Indiana, Wisconsin, and Michigan. Archibald's second wife, Dorothy (left), served as Fannie May's chief executive officer after his death in 1936.

The first Fannie May shop, located at 11 North LaSalle Street, advertised its "home made" candies "made fresh today—and every day." The grandmotherly name was pure invention, used to add to the store's homey appeal. Inside, however, customers found something even more appealing—all Fannie May candies sold for 70¢ per pound at a time when most similar candies sold for 90¢ to $2 per pound. A price-slashing war quickly ensued.

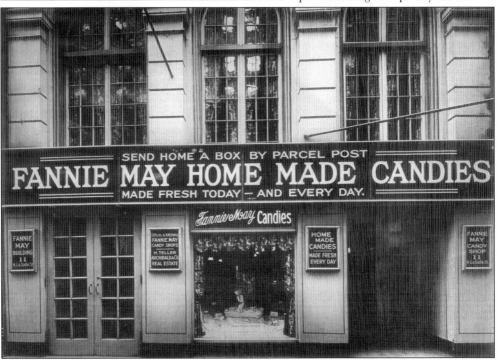

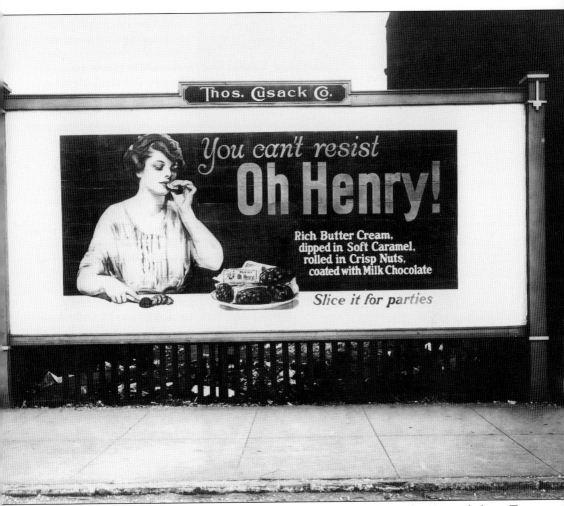

When it first appeared in 1920, Oh Henry! cost 10¢—twice the cost of most candy bars. To convince people to spend a dime instead of a nickel, Oh Henry! creator George Williamson devised new methods of promoting and distributing his candy. Billboards like this coordinated with streetcar advertisements, store-window displays, and newspaper and magazine advertisements, and the promotional blitz worked. Within four years, Oh Henry! was America's top-selling candy bar. When asked how Oh Henry! got its name, Williamson told the story of how he was running a small candy shop on Madison Street, across from the Morrison Hotel. A young man named Henry frequently popped in to flirt with the young female clerks. When the women saw him, they would call out, "Oh, Henry!" Soon after, a salesman suggested they call their new candy "Oh Henry!"—it was all they ever heard. (Library of Congress, Prints and Photographs Division, LC-USZ62-83203.)

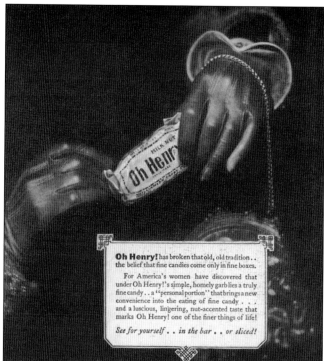

This advertisement positioning Oh Henry! as an affordable luxury chocolate reads: "Oh Henry! has broken that old, old tradition . . . the belief that fine candies come only in fine boxes." George Williamson worked hard to convince women—long considered the primary consumers of fine candy—to shift to the new candy bar format. Williamson's Oh Henry! bars came in convenient "personal portions" and could be served sliced wherever boxed chocolates were desired.

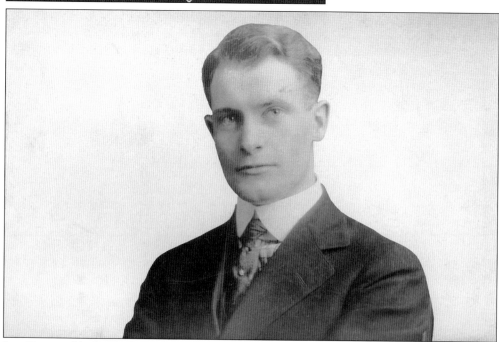

Just 32 years old when he launched Oh Henry!, George H. Williamson believed consistent quality would build the confidence of dealers and consumers. "We have made many million Oh Henry! bars—and, as far as is humanly possible, we have made every single one of those bars exactly like the first," he declared in a 1925 publicity booklet. Initially a salesman for a candy broker, Williamson ran his own candy shop before deciding to focus solely on candy manufacturing.

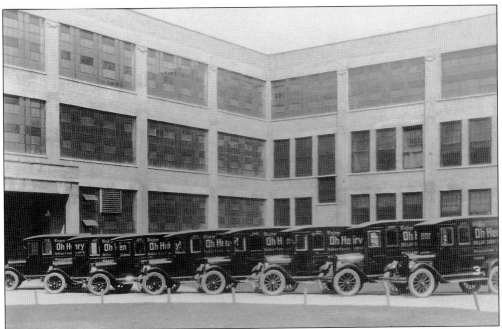

Trucks parked outside the new Williamson Candy Company factory at 1039 North Ashland Avenue testified to Oh Henry!'s growing popularity. This image was taken for a fold-out display of Williamson factory photographs intended to illustrate the company's technological expertise and state-of-the-art equipment. The new plant, which opened in 1924, featured 96,000 square feet of floor space. It produced only Oh Henry! bars, which were then Williamson's sole product.

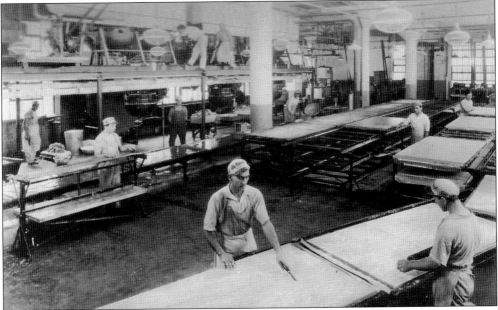

Oh Henry! bar production began with the buttercream centers. Workers mixed and cooked the ingredients in enormous kettles, then poured the mixture onto large slabs. Once cool, the slabs were scored and broken into thousands of individual centers. As in most candy factories of the era, men did the heavy work of lugging supplies and working with vats of hot sugar-based mixtures.

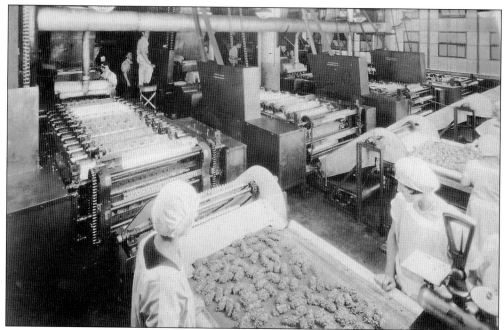

After the buttercream Oh Henry! centers were broken into pieces, belts carried them into machines in which they were coated with caramel and rolled in peanuts. Here, masses of partially finished bars glide down wide, moving belts.

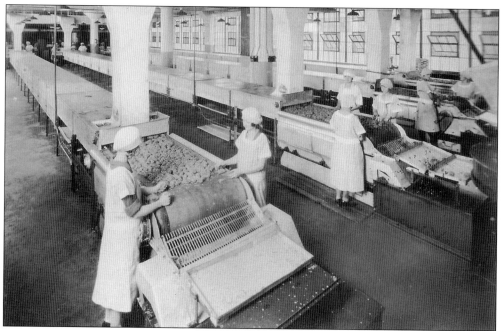

After being coated with caramel and peanuts, the candy bars moved into 140-foot-long machines for cooling. Maintained at a precise temperature, the cooling tunnels ensured that the caramel and peanuts were firmly attached. Candy bar centers glided through the machines at a rate of 18,000 per hour.

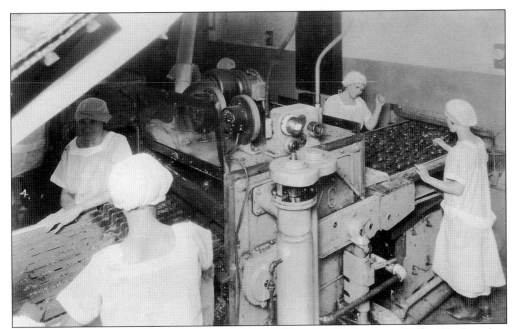

The Oh Henry! bars then passed through the enrobing machines to get their milk-chocolate coatings. Enrobers, which resemble chocolate waterfalls, transformed the time-consuming labor of hand-dipping candy centers into a fast, mechanized process. Williamson Candy could coat hundreds of Oh Henry! candy bars in the time a worker might have been able to hand-dip a few dozen. From here, continuous belts moved the finished bars into the cooling and packing rooms.

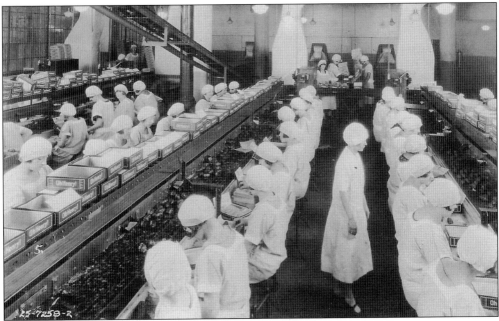

In the packing room, workers—typically women—individually wrapped each candy bar and packed them into boxes. Every eight hours, each conveyer belt carried 15 to 17 tons of candy bars into this room.

OH HENRY! TOAST
FOR AFTERNOON TEA
Originated by C. B. K.

4 thin slices white bread	Butter 1 bar Oh Henry!

Toast the bread golden brown, remove the crusts, butter, cut each slice into halves, then lay on each piece very thin slices of Oh Henry! allowing these to almost touch. Place in a hot oven—375-400 degrees F.—for from three to four minutes to allow Oh Henry! to heat and soften. Serve at once.

OH HENRY! WITH TOASTED CHEESE
Originated by Miss Gracia Shull, Muskegon, Mich.

Soda crackers	Grated cheese
	Thin slices of Oh Henry!

Place soda crackers close together in a flat baking pan. Cover them thickly with grated cheese and place a thin slice of Oh Henry! in the center of each cracker. Bake in a moderately hot oven until the cheese is slightly browned and the Oh Henry! begins to melt. Serve immediately.

Biscuits for Sunday tea, page 36

[22]

In 1926, Williamson asked women to send in their favorite recipes using Oh Henry! bars. Cooks across the country submitted more than 8,000 recipes for cakes, pies, ice cream, stuffed tomatoes, sticky buns, and—pictured here—toast for afternoon tea. The resulting booklet, *Sixty Ways to Serve a Famous Candy,* gave readers clear-cut directions for using Oh Henry! at any meal as well as implying that women across the country were buying it.

A glut of knockoffs prompted Williamson to offer a tongue-in-cheek Copy of Oh Henry!: "Due to the wide spread practice of imitating Oh Henry!, we, the sole makers of that justly famous candy bar, feel that it is our duty to the candy loving public to offer the finest imitation of Oh Henry! that can be made for 5¢." Yielding to consumer preference, Williamson debuted an official 5¢ Oh Henry! in 1928. (Richard Saunders, candywrapperarchive.com.)

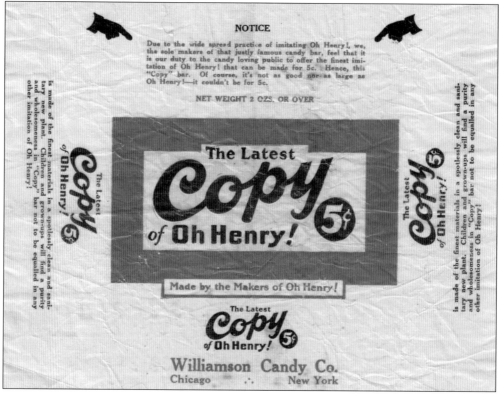

Williamson's Guess What? consisted of several candy kisses wrapped up with a surprise novelty. Calling Oh Henry! the candy bar with "the first of the screwy names," Williamson thought up similarly whimsical names for many of his candies, including Oh Mabel!, Oh Nuts!, and That's Mine! Candymakers around the country followed suit, unveiling bars with zany names like Smile-A-While, Dipsy Doodle, and Chewy Louie.

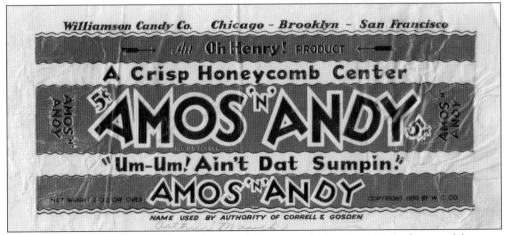

Williamson Candy Company also made a candy bar named after *Amos 'n' Andy*, one of the most popular radio programs ever broadcast. The popularity of *Amos 'n' Andy* peaked in the early 1930s, as did that of its namesake chocolate-covered honeycombed candy bar. (Richard Saunders, candywrapperarchive.com.)

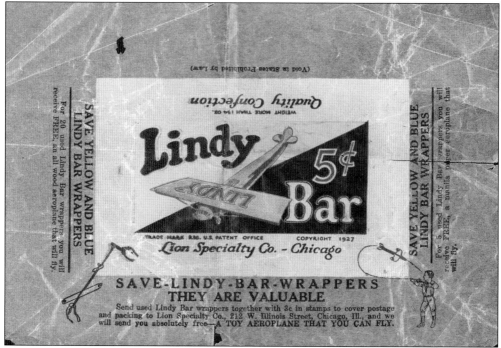

When Charles Lindbergh became the first aviator to fly solo nonstop across the Atlantic Ocean in 1927, at least 10 companies introduced Lindbergh-themed candy bars. The Lindy Bar, made by the Lion Specialty Company of Chicago, included a promotion for a toy airplane. The famous pilot received no royalties for any of the bars that capitalized on his popularity.

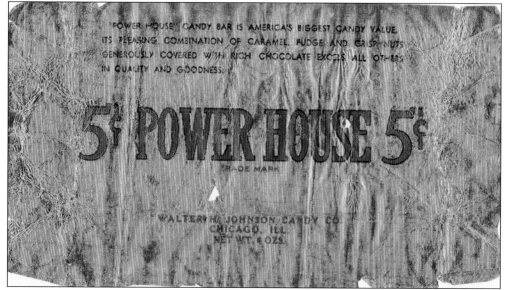

When the Walter H. Johnson Candy Company introduced its hefty peanut, fudge, and caramel Power House bar, it sold for 5¢ but weighed four ounces—twice that of most bars, then or now. The size later shrank, but Johnson reintroduced the four-ounce version in 1953 . . . for 10¢. The Peter Paul Candy Manufacturing Company continued to make Power House after purchasing Johnson in 1966; Hershey discontinued it around 1988.

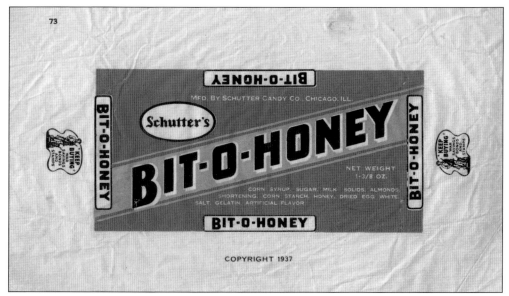

Not many candy bars could be made from taffy. Bit-O-Honey, which first appeared in 1924, was a rare exception. Originally made by Chicago's Schutter-Johnson Company, the bar consisted of a honey taffy flecked with almond bits and scored into six pieces. Besides the taste, its appeal lay in its long-lasting chewiness. Schutter-Johnson split up around 1936, with Walter Johnson forming his own company, mentioned earlier. (Richard Saunders, candywrapperarchive.com.)

William Wrigley Jr. himself chose the spot for his company's dazzling glazed terra-cotta skyscraper on Michigan Avenue. His choice was, as always, visionary. When ground was broken in 1920, construction had just begun on the nearby Michigan Avenue bridge that would open up development of the north Michigan Avenue business district—the Magnificent Mile. The "house that gum built" became one of Chicago's famous landmarks and remained Wrigley's corporate headquarters until it was sold in 2011.

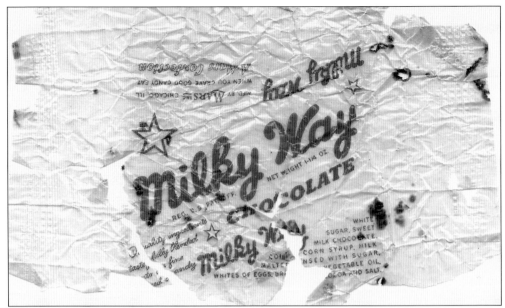

Small-time Minneapolis candymaker Franklin "Frank" Mars developed the Milky Way, introduced in 1923, to taste like the latest ice cream shop sensation, the malted milkshake, which was invented at a Walgreens drugstore in Chicago just one year earlier. This crumpled Milky Way wrapper shows the early popularity of semitransparent wrappers that let customers see the product while keeping it sanitary. *Confectioners' Journal* later praised Mars wrappers for their "subtle and dignified appeal."

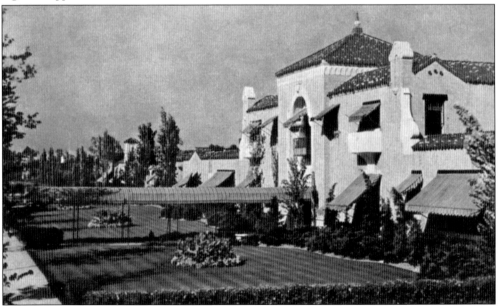

With demand for Milky Way skyrocketing, Frank Mars left Minnesota and opened the company's first large-scale manufacturing operation on Chicago's Far West Side in 1929. Designed in Spanish Renaissance style, the posh factory featured a pristine lawn and a 100-foot-long canopy stretching to the sidewalk. One newspaper believed it boosted neighborhood home sales. Frank Mars believed that proximity to a residential neighborhood would attract high-quality employees.

Mars helped persuade buyers of Milky Way's wholesome nourishment by putting an image of a glass-lined milk tank in advertisements. Milky Way was not named for the celestial body, insisted Mars, but for "the milky way it was made," with milk in the nougat, caramel, and chocolate. Reflecting lingering fears about adulterated candies, Mars also barraged consumers with messages about the purity of its candies and the cleanliness of its sunshine-filled factory.

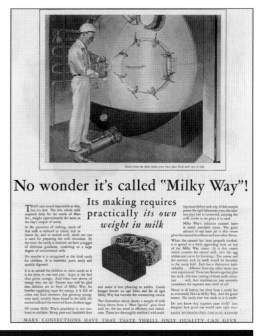

No wonder it's called "Milky Way"!

Its making requires practically *its own weight in milk*

MARS CONFECTIONS HAVE THAT TASTE THRILL ONLY QUALITY CAN GIVE

For years, Mars put photographs of its swanky factory on its candy boxes. But the factory was about more than good looks. Frank's son Forrest Mars maintained that the Chicago plant made up to 20 million candy bars annually. Forrest also claimed he had encouraged the move, citing transportation costs: "I told my dad, 'The freight rate in Chicago is half that of Minneapolis … with this rate, we can really make some money.' "

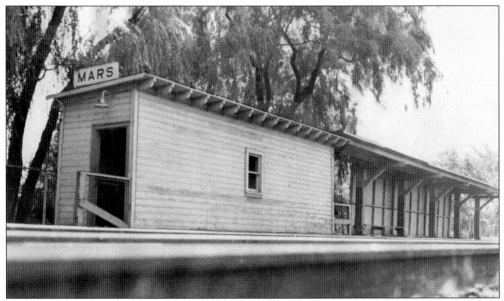

To serve the many Mars employees who commuted to the factory each day, the Chicago, Milwaukee, & St. Paul Railroad opened a station near the factory in 1938. The station, now part of the Metra commuter rail's Milwaukee District/West line, retains the name "Mars" to this day, and a walkway still allows passengers to enter the factory directly from the train station.

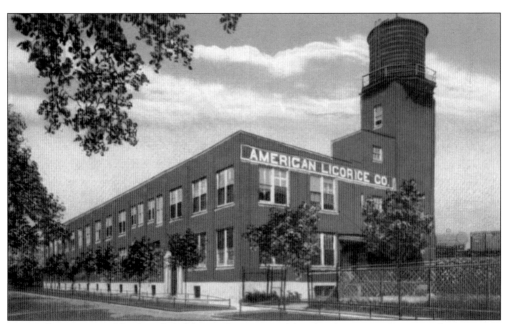

On Halloween, neighborhood children often stopped by the American Licorice Company at Keystone and Belden Avenues for its pastel-colored licorice Snaps. Founded in 1914, the company operated this factory until the 1980s (most Chicago work relocated to Alsip, Illinois, in 1976). American Licorice remains a major player in the licorice business, with additional operations in California, Oregon, and Indiana. It is beloved for its Red Vines, Super Ropes, Sour Punch Straws, and Snaps.

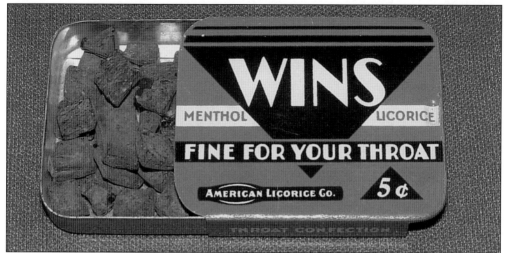

American Licorice soothed smokers' throats with a menthol-licorice confection sold in pocket-sized tins. The link between candy and medications is a long one, probably dating back to early apothecaries who disguised the taste of medicine with sugar and honey. Many candy companies sold variations of their candies adjusted to soothe minor ailments, just as drug corporations worked with confectioners to create medicated candy.

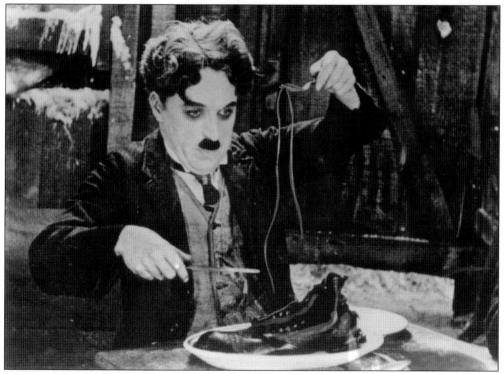

The American Licorice Company created a licorice boot for a starving Charlie Chaplin to eat in the 1925 movie *The Gold Rush*. "I got the idea for this gag from the Donner party [pioneers trapped in the Sierra Nevada in 1846]," Chaplin recalled in *Chaplin: Genius of the Cinema* by Jeffrey Vance. "They resorted to cannibalism and to eating a moccasin. And I thought, stewed boots? There's something funny there." (*The Gold Rush* © Roy Export S.A.S.)

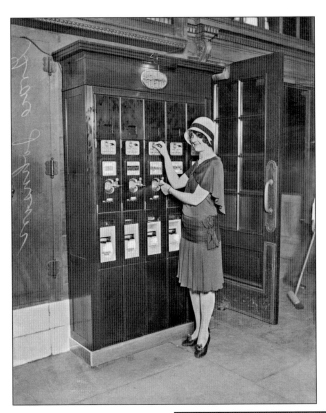

Grace Johnson slips a coin into a Chicago candy slot machine in 1929. Coin-operated machines made candy bars—with their uniform size and single-serve sanitary packaging—convenient and accessible. General-line candies (gum drops, taffy kisses, caramels, peppermints, and so on), by contrast, were mostly limited to sales in grocery and chain stores. Vending machines also boosted impulse sales. By the late 1950s, nearly 90 percent of candy was purchased on impulse. (Chicago History Museum/ Chicago Daily News negatives collection, DN-0088322.)

Punchboards like this enticed customers to pay a nickel for a chance to punch open a hole with a small stylus and retrieve a small ticket listing a prize. Candy shop owners also used gum or candy vending machines that occasionally returned specially colored candies redeemable for prizes. These unlicensed forms of wagering peaked in popularity in the 1930s but fell out of favor amid fears they instilled gambling habits in children.

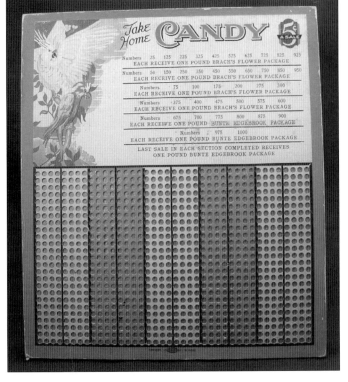

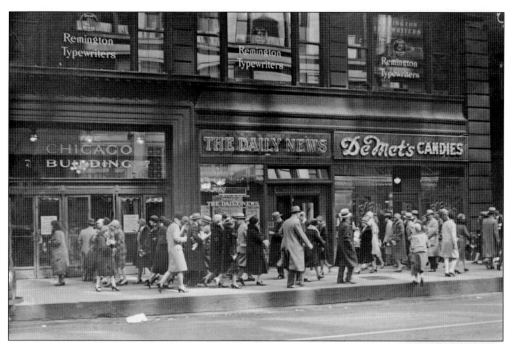

Pedestrians stroll past a DeMet's candy store and soda fountain on Madison Street in 1929. Nicholas and George DeMet emigrated from their native Greece to Minneapolis, but when a fire destroyed their candy store, the brothers moved to Chicago to join a cousin who operated a business known as Johnson's Candy Stores. In 1923, the Johnson name disappeared and DeMet's emerged. (Chicago History Museum/Chicago Daily News negatives collection, DN-0087763.)

This DeMet's shop on Randolph Street (left) was ideally situated for patrons of the new movie palaces in the Loop. The marquee advertising *A Farewell to Arms* at the Oriental Theater across the street dates this photograph to 1932. Throughout the 1920s, more DeMet's stores were added, including locations in the Garland Building, the Board of Trade, and the One North LaSalle Building; the DeMet's chain eventually included 12 stores. (Chicago Transit Authority.)

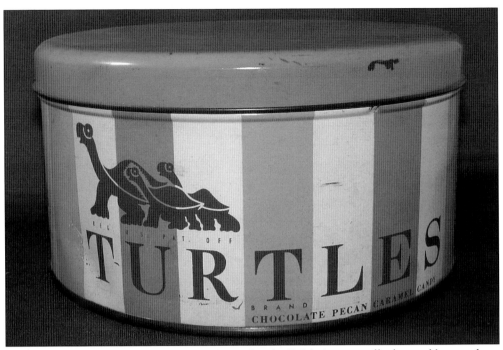

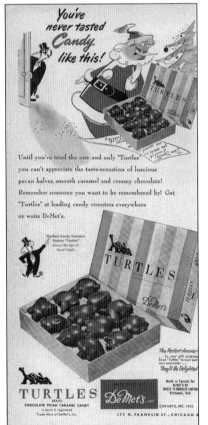

A supplier for DeMet's reportedly dropped by one day and showed one of the dippers a new candy from New York. "It looks like a turtle," she exclaimed. Soon, DeMet's was selling a similar chocolate, pecan, and caramel candy called a "turtle." "Pecans dipped in chocolate were commonly made at the time, but we had a patent on the name, so we were the only ones who could use it," George DeMet later explained.

Turtles debuted to modest esteem, but their popularity soon soared. By the 1950s, Turtles were selling nationwide and appearing in major magazine advertisements. After a series of mergers and acquisitions, the name DeMet's went dormant when Nestlé purchased the Turtles brand in 1988. Nestlé in turn sold the brand to an investment group that revived the name DeMet's Candy Company.

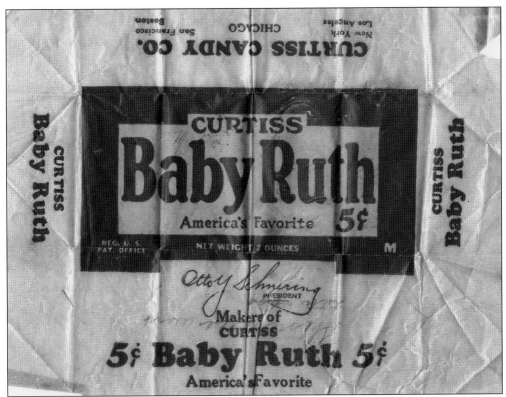

In later years, creator Otto Schnering, founder of the Curtiss Candy Company, claimed that his Baby Ruth bar was named for Grover Cleveland's daughter Ruth, not baseball superstar George Henry "Babe" Ruth; historians are skeptical. Ruth Cleveland died 17 years before the candy debuted in 1919. Moreover, the bar appeared just as Babe Ruth became the most famous athlete in America. The famous slugger hit a record 29 home runs in 1919 and a mind-boggling 54 home runs in 1920.

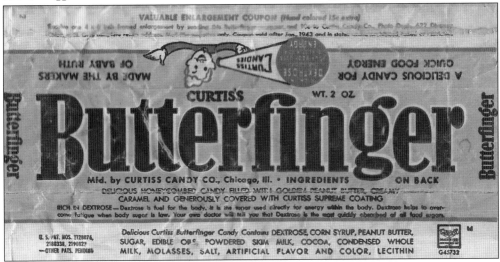

Schnering's second major candy hit was Butterfinger, introduced in 1923. The crispy, flaky peanut butter bar reportedly got its name from the slang term sportscasters used for an athlete who could not keep a grip on a baseball or football.

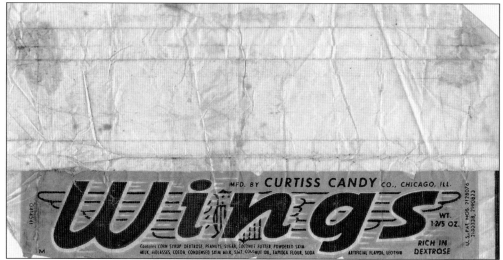

Curtiss Candy Company briefly offered a crunchy bar with a caramel filling called Wings. The aviation-themed name might have been an attempt to capitalize on the similarity between the company's name and that of aircraft manufacturer Curtiss-Wright. Schnering had a knack for names—when founding his company in 1916, he avoided his own German-sounding last name and chose his mother's maiden name, Curtiss, instead.

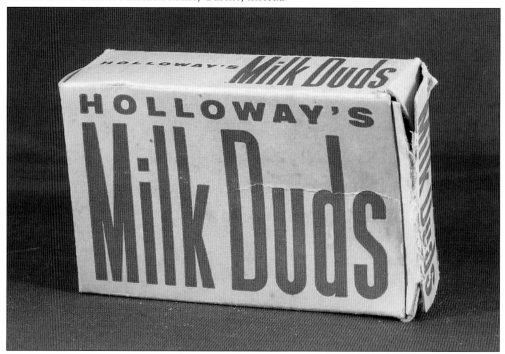

According to legend, candy manufacturer F. Hoffman and Company invented Milk Duds while trying to make a perfectly round chocolate-covered caramel. When the machines kept churning out flattened, misshaped caramels, Hoffman simply named them "duds." Milton J. Holloway took over the company in 1928 and made a fortune selling Milk Duds, Slo Pokes, and other chewy treats. After a series of acquisitions, Milk Duds were acquired by the Hershey Foods Corporation in 1996.

The Chicago-based White-Stokes Company published this booklet of recipes for nougats, caramels, fudges, and creams, all made using its own fondant and cream bases. White-Stokes was one of many local suppliers serving Chicago's confectionery industry. As new machinery made candymaking easier than ever, these suppliers found a ready market in drugstores, five-and-dimes, and department stores, many of which began producing their own candies.

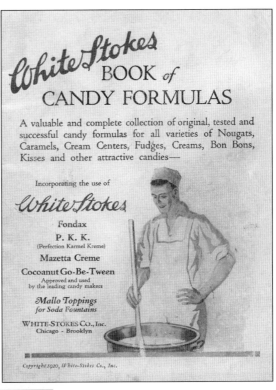

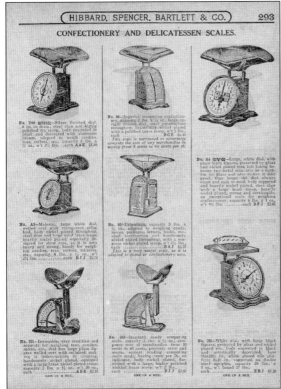

The venerable Chicago hardware company Hibbard, Spencer, Bartlett & Company sold confectionery scales in its 1915 catalog. The diversity of sizes and prices testifies to the importance of scales in the confectionery business. Until the 1920s, most candy was still sold loose from barrels or boxes; sellers scooped loose candy into scales and sold it by the pound.

59

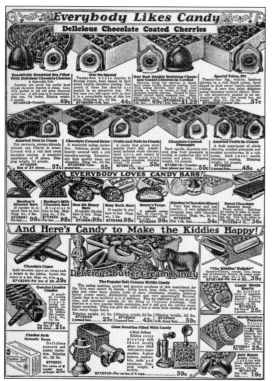

The 1927 Sears, Roebuck and Co. catalog included both generic candies (possibly made by Sears itself or purchased from bulk manufacturers) and such brands as Kraft marshmallows and Peerless Maid filled candies. Catalogs, which brought modern life to rural and farm customers, profoundly shaped contemporary ideas about material comfort. Mass-produced, trademarked candies now ranked among the commodities that consumers could use to create and reinforce their identities as modern Americans.

Ora Hanson Snyder chose sites where men congregated, including the Hamilton Club and the Board of Trade Building. "Men are the great candy buyers," she explained. "They buy it not only for their wives . . . but also for themselves." By 1941, she needed a seven-story factory and 300 workers to make the candies for her retail stores. A Mrs. Snyder's storefront, pictured in 1946, bears her signature elegance. (Chicago History Museum/Hedrich-Blessing, HB-09578.)

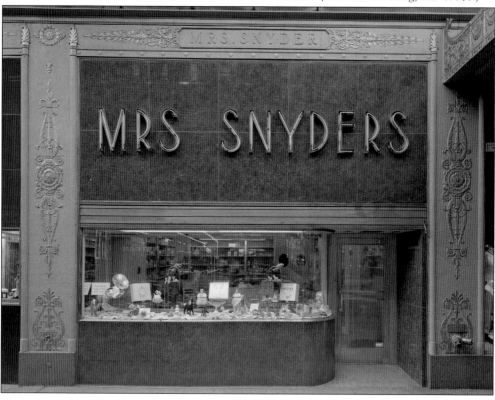

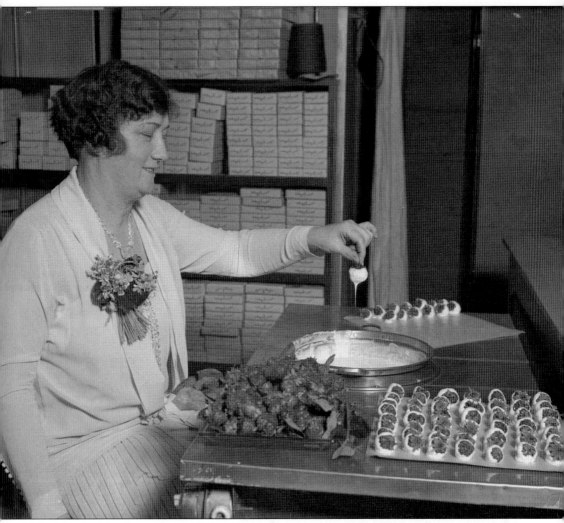

Melted candy drips from the tip of a strawberry in this 1925 press photograph of Ora Snyder—better known as "Mrs. Snyder"—demonstrating candy dipping. Just six years after this photograph was taken, Snyder was elected the first woman president of the Associated Retail Confectioners of the United States. By the time she passed away in 1947, Mrs. Snyder's had 16 Chicago stores. It was a dizzying rise for Snyder, who began her career as a confectioner when her husband was forced to quit his job in 1909. She had the skills—while growing up, her father banned commercial candy for fear of adulteration but permitted his children to make all the candy they wanted. As a professional candymaker, Snyder tapped into deeply rooted cultural ideas about safe, wholesome candymaking in the home and women as family caretakers. Mrs. Snyder's was later purchased by Andes Candies. (Photographic History Collection, Division of Information Technology and Communications, National Museum of American History, Smithsonian Institution.)

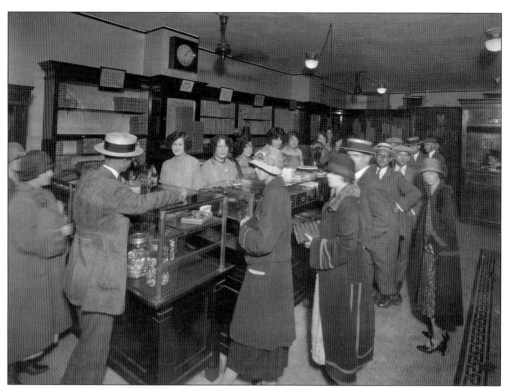

In this 1927 image, shoppers pack Mrs. Snyder's Michigan Avenue shop. In later years, Snyder loved describing how her initial outlay was just a nickel used to purchase sugar for her first batch of fudge; she sold that fudge in a neighborhood school store. Before long, she was downtown selling candy from a peanut shop on State Street and eventually from her own shops. (National Archives, photograph no. 522874.)

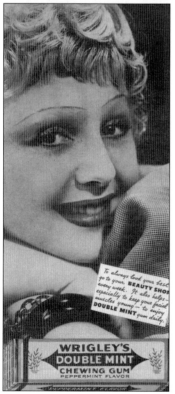

A lovely girl sporting glossy lips and well-plucked eyebrows served as the visual embodiment of the beauty benefits of gum chewing. Daily chewing of Wrigley's Doublemint gum, according to this advertisement, would keep one's facial muscles young.

Four

THRIVING IN
DEPRESSION AND WAR
1930s–1940s

The National Confectioners Association (NCA) devised this humorous display of proper merchandising for a 1930 Chicago candy industry convention. On the left, a bored clerk leans on a disorganized merchandise case. The "correct" display at right has modern fixtures, orderly displays, and a sign reading "No meal is complete without candy." The NCA lamented that so few store owners arranged attractive, clean displays and encouraged merchandising and salesmanship. (Library of Congress, Prints and Photographs, LC-USZ62-73628.)

The William Wrigley Jr. Company got into radio when vaudevillian Myrtle Vail dreamed up a drama about a mother-daughter chorus team with the names Myrtle Spear and Marge Minter (thus "Spear-Minter"). *Myrt and Marge* debuted in 1931 as a nighttime drama starring Vail and her real daughter Donna Damerel. Full of adventurous crime twists, the popular show eventually moved to daytime and generated a film adaptation featuring the Three Stooges.

One-cent candies were nothing new, but one-cent candy bars did not appear until the Great Depression. Some of the earliest came from Otto Schnering (and his Curtiss Candy Company), who also began to run his plants on short four- or six-hour shifts during the Depression to allow the maximum number of employees to work. Buy Jiminy was a peanut candy bar, while Dip was a chocolate candy with a soft nougat center.

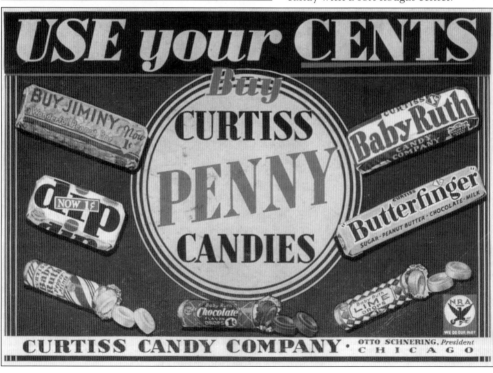

A toddler bearing a Baby Ruth beach ball unwittingly became one of thousands of Curtiss candy promoters. Few candymakers showed such zeal for promotional items as Schnering. He emblazoned "Baby Ruth" on matchbooks, pocket knives, tissue packets, stuffed dolls, and even on the sides of circus elephants. In 1928, annual production of Baby Ruth bars amounted to 1 billion bars, requiring 45 million pounds of shelled peanuts and milk from 5,000 cows.

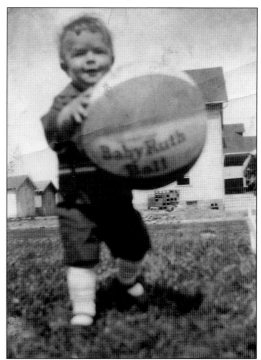

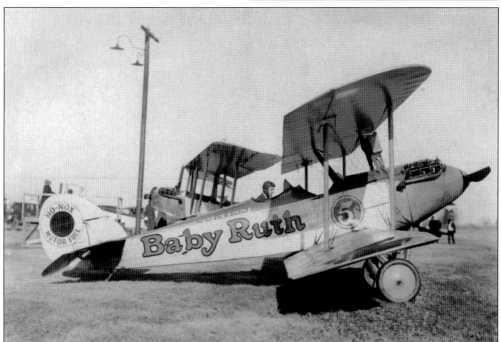

Curtiss frequently sponsored planes in early air competitions. The winner of one air race, held at the Chicago airport in 1933, received the "Baby Ruth trophy" valued at $2,500 ($41,600 in 2010 dollars). As an advertising gimmick, the company dropped candy bars attached to parachutes from airplanes over Pittsburgh. It proved so successful, the company repeated the stunt over 40 American cities. (LSU-Shreveport Archives and Special Collections.)

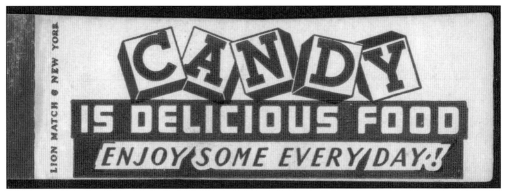

Taking a cue from the Florists Telegraph Delivery Association, which had increased sales with the snappy motto "Say it With Flowers," the National Confectioners Association poured efforts into devising its own promotional slogan. A committee headed by Otto Schnering developed the slogan "candy is delicious food—enjoy some every day," which debuted in 1938. The phrase quickly popped up on matchbook covers, window transparencies, envelope stuffers, and advertisements.

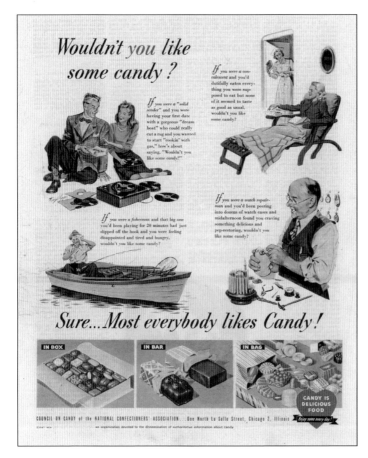

The National Confectioners Association hammered away at the message that candy is a food with advertisements showing candy being enjoyed in a variety of everyday situations. In advertisements like this, the NCA outlined candy's food components and stressed the role of candy in the everyday diets of soldiers, athletes, explorers, and children. "Candy is a food. And that fact can never be driven home too often," argued the *Confectioners' Journal.* "Candy is *not* a luxury."

Eighteen-year-old Mary Jeanne Drake, a Curtiss bookkeeper, won a gumdrop crown and popcorn-ball scepter after beating 34 other contestants to earn the title "Sweetest Girl" in the Midwest candy industry in 1938. The contest was part of the first Chicago Candy Show, an exposition that drew more than 25,000 attendees to the Hotel Sherman. The show also featured a taffy-pulling competition, a lollipop-sucking contest, and, yes, meetings on management and sales issues.

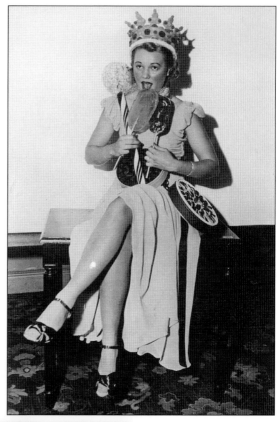

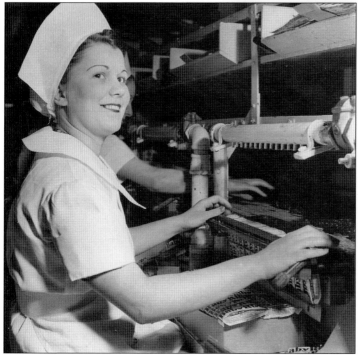

With a quick flash of smile, Marie Tabor glanced up from her station on the Baby Ruth wrapping machine in 1939. Touted as "the latest thing in candy protection," the machine blew open each wrapper with a blast of air for easy filling. A lever closed the package, crimping the edges together. The only hands to touch its candies, Curtiss claimed, were those of the worker who slipped the bar into its wrapper.

In this photograph, Helen Mizula and Rose Sciulara did not even pause to look up from their work monitoring the machines that were coating 1¢ Baby Ruth centers in caramel and peanuts at the Curtiss Candy Company. In the early 1940s, one Curtiss factory claimed it could make 2.5 million penny chocolate bars per day.

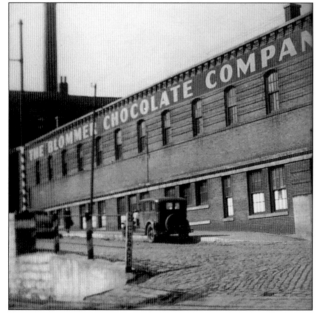

Kinzie Street was still paved with brick when the Blommer Chocolate Company opened in 1939. Although raised in dairy-rich Wisconsin, Henry Blommer Sr. and his brothers Aloysius and Bernard chose Chicago to be close to their candy-manufacturing clients. To this day, Chicagoans know the factory from the aroma of warm melted chocolate that often drifts in the air near 600 West Kinzie Street. (Blommer Chocolate Company.)

It reportedly took three years to create the peanut, caramel, and nougat Snickers bar, launched in 1930. It was worth it. Now heralded as the greatest selling candy bar of all time, Snickers boasts annual sales of nearly $2 billion, requiring daily production of more than 15 million bars. Frank Mars named the bar after one of the family's favorite horses. Whoever thought to enhance it by freezing it (see upper right) remains unknown.

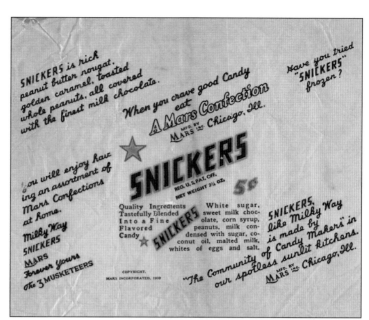

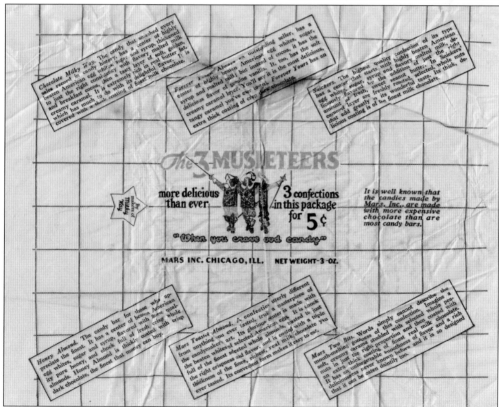

When it first appeared in 1932, Mars' 3 Musketeers bar came in a package of three pieces, each with a separate strawberry, vanilla, or chocolate center. Rising costs and wartime restrictions led to the phasing out of the vanilla and strawberry pieces in favor of one bar with a chocolate center. (Richard Saunders, candywrapperarchive.com.)

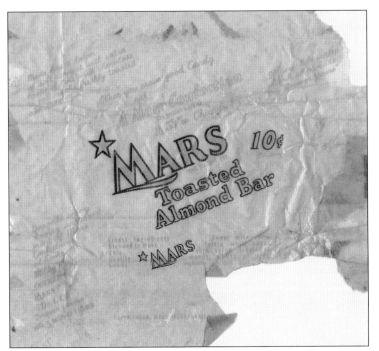

Mars' almond, caramel, and nougat candy bar had numerous names over the decades, including the Toasted Almond Bar. The name changed to Mars bar when the recipe was tweaked in 1980 (causing some confusion to the British, who had been enjoying their own Milky Way–like "Mars" bar since 1932). In 1990, the American bar became the Mars Almond Bar. Finally, after another tweaking, it reemerged as the Snickers Almond Bar.

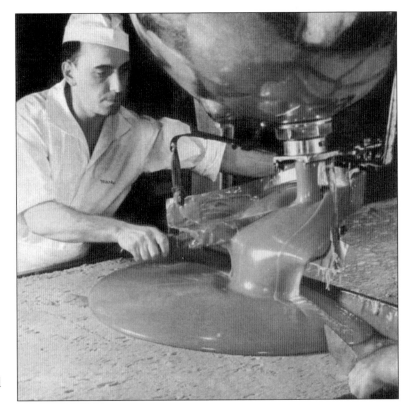

Using one hand to guide the kettle and another to spread, a Mars employee pours caramel over a pan of nougat in this image from a 1930s Mars behind-the-scenes guidebook. Although Mars boasted a state-of-the-art factory, much of the work in this era was still done by hand.

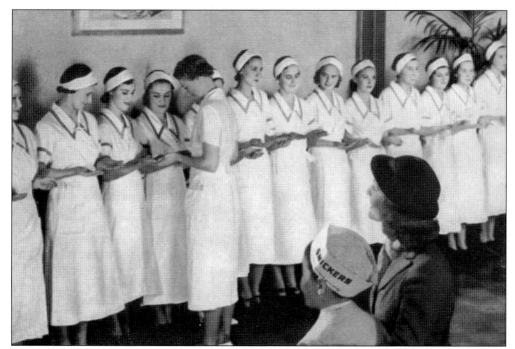

Mars workers underwent hand and fingernail inspections daily. As part of its strict hygiene requirements, the company banned jewelry, insisted on spotless white uniforms, and required job applicants to pass a physical examination. Mars also scoured its floors up to five times daily and scrubbed and steam-sterilized its kettles regularly.

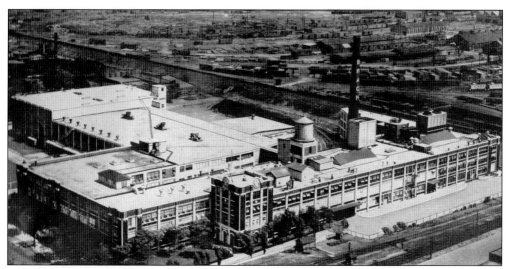

A brick smokestack emblazoned "Brach" towers over the candymaking factory. By the time of Emil Brach's death in 1947, the factory had been expanded several times to include new shipping and candy conditioning facilities, a modern chocolate-grinding plant, and space for 2,000 employees. The Chicago factory kept growing, eventually becoming the country's largest candymaking facility, producing four million pounds of candy weekly by the end of the 1950s.

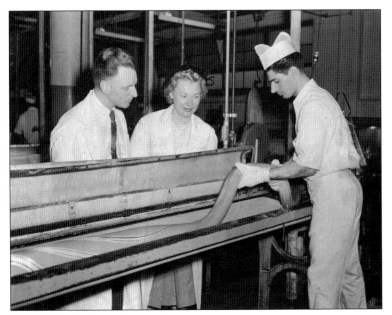

Like a snake-handler manipulating a boa constrictor, a Brach's worker demonstrates how he maneuvers a long roll of striped candy. Previous workers had created the striped design by adding narrow strips of colored candy to the roll. Now, the roll would be stretched further into a long thin log and cut into finished pieces.

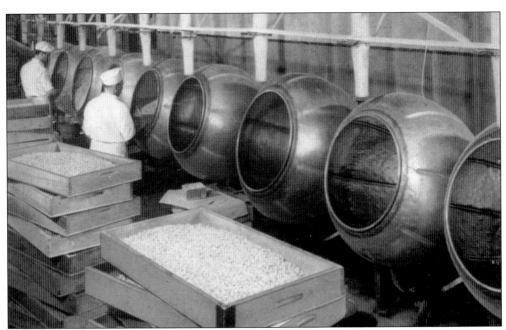

A line of kettle-like panning machines gleam in the Brach's factory in the late 1940s. The panning process, which dates back to the 17th century, involves building up a candy from a small center, such as a nut or piece of candy. As the pans revolve, skilled workers toss in syrups, flavorings, colorings, and other ingredients, gradually building up a smooth candy shell, often finished with a shiny coat of edible wax. Jelly beans, jawbreakers, and candy-coated peanuts are all made by panning.

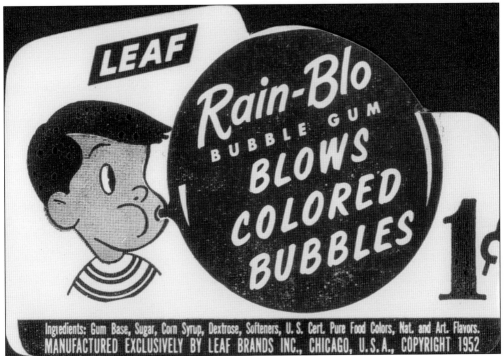

Rain-Blo gumballs, introduced in 1940, got their fruity tang from flavoring that was colored to match the outside candy coating. As a result, they were the first gumballs that let chewers blow colored bubbles. Sol D. Leaf started several candy companies in the 1920s that eventually merged to form Leaf Brands in 1947. It evolved over time from a general line house into a specialties firm. Today, Farley's & Sathers Candy Company makes Rain-Blo.

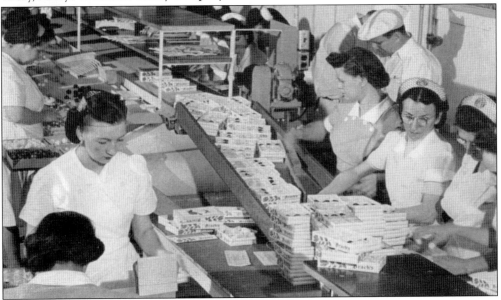

Workers pack Brach's higher-quality Rose Line candies into boxes and cellophane bags. Rose Line candies, which included candy corn, spice jellies, Kentucky mints, orange slices, and so on, came in boxes with cellophane windows.

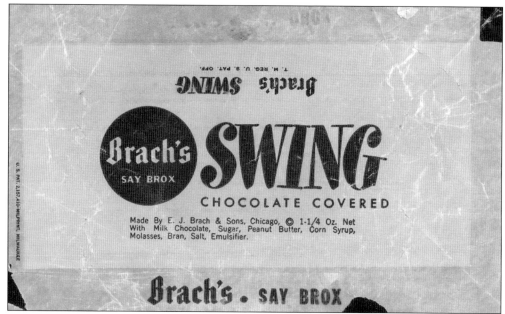

Brach's chocolate-covered, honeycombed, peanut butter Swing Bar was one of America's most popular candy bars prior to World War II. Although they are largely forgotten today, Brach's made several candy bars, including a mint bar and an almond nougat bar. The company phased out most candy bar production by the 1940s, turning its attention to bulk and bagged candies. Note the helpful pronunciation tip: "Say Brox."

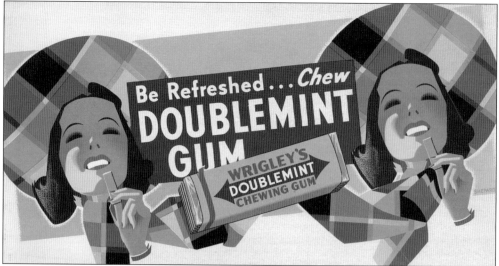

Famed Wrigley art director Otis Shepard pioneered a new direction in visual advertisement with bold, graphic illustration, such as this Doublemint advertisement that uses minimal text, vivid colors, and eye-catching imagery. Launched in the 1930s, the long-running Doublemint twins campaign began in the 1930s and remained popular for decades. Interestingly, Doublemint gum did not feature two "twin" mint flavors but rather a double-distilled peppermint flavor. (Library of Congress, Prints and Photographs, LC-USZC4-13909.)

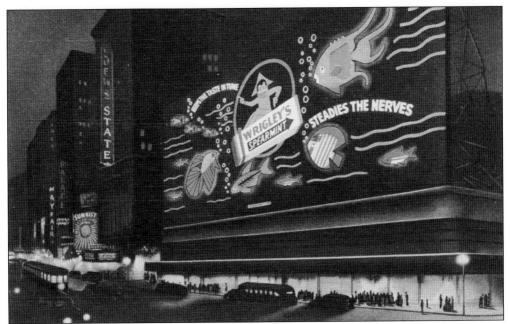

In 1936, Wrigley's unveiled a splashy, block-long billboard in New York's Times Square that featured more than 1,000 feet of neon bubble–blowing tropical fish. Some of the unique neon colors were created for the sign. The spectacular tableau remained until 1960, with a brief hiatus during World War II. In 2001, Wrigley unveiled another oversized, illuminated billboard one block south of where this one stood, touted as "Wrigley's historic return" to Times Square.

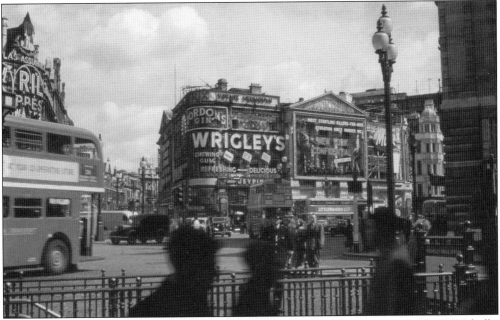

For 40 years, a giant Wrigley's neon sign lit up London's Piccadilly Circus, aided by 7,700 bulbs and 150 miles of wiring. Although the British had resisted gum-chewing, the habit took off during World War II, when American GIs living in Britain received Wrigley's gum in their rations. In an era of wartime austerity, the British began to view gum as a stylish luxury item.

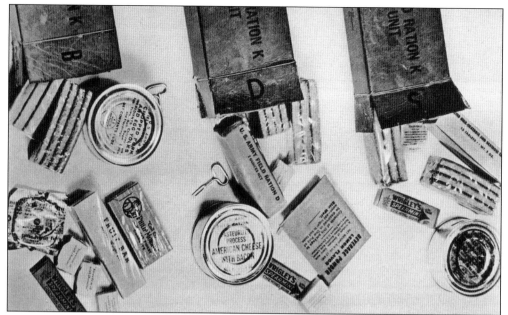

A one-day sample of US Army "K," or combat, rations included a stick of Wrigley's gum for breakfast (left), dinner (center), and supper (right). Wrigley contributed heavily to soldier rations during the war, as did most confectioners. Candies of all sorts made excellent combat food, argued the National Confectioners Association, because they were easy to eat, high in calories, "take up little space and weight, have good stability, make excellent survival rations and . . . contribute to morale."

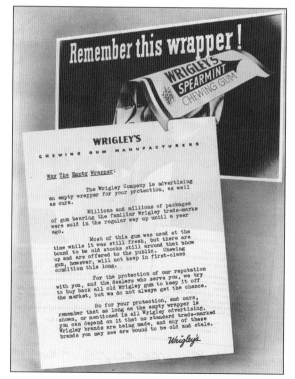

Wrigley's scored an advertising triumph with its "Remember this wrapper" campaign during World War II. When sugar rationing curtailed civilian production, company president Philip Wrigley boldly announced that the entire output of Doublemint, Juicy Fruit, and Spearmint gum would go to US military forces. Advertisements communicated with minimal simplicity both the company's patriotism and also a positive message about the war's eventual end.

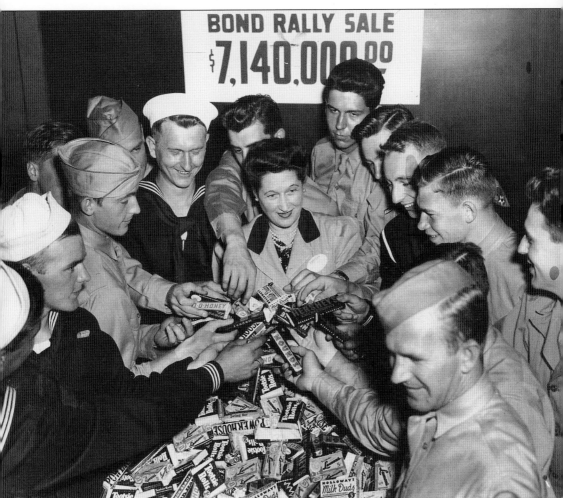

Servicemen throng Margaret Kelly, wife of Chicago mayor Edward J. Kelly, for some of the 80,000 candy bars donated from around the country to the Chicago Servicemen's Centers in 1943. Candy bars were among the home-away-from-home comforts provided free of charge to the thousands of servicemen passing through the city daily during World War II. At a time when many candy bars were hard to find, candy donations were a valuable way to thank soldiers for their service and encourage postwar brand loyalty.

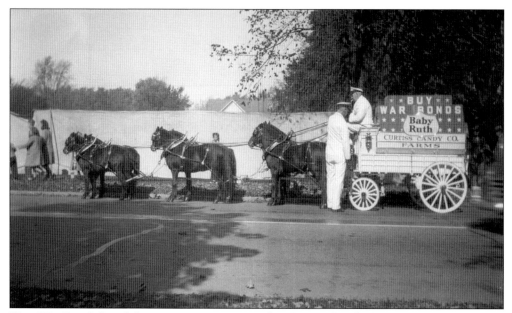

"Buy War Bonds," said the encouraging sign on this Curtiss Candy Company six-pony wagon hitched for a wartime parade. By the 1950s, the company had four of these custom-made miniature express wagons. They appeared at children's institutions, rodeos, livestock shows, and parades throughout the Midwest. Employees remember picnics at Curtiss Farms in Cary, Illinois, that included wagon rides for the children across the farm's rolling hills.

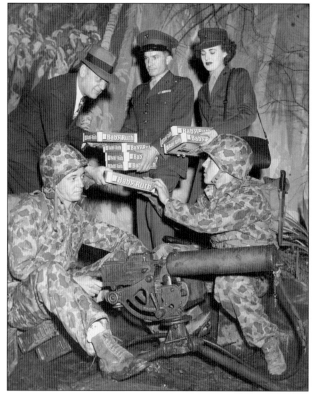

Otto Schnering was so impressed with a jungle scene at Chicago's Navy Pier that he donated 10,000 candy bars to the Marines. William C. Moller (left, standing), treasurer of Curtiss, presented the candy to Lt. Col. G. McGuire Pierce (center, standing) of the Marine Provisional Battalion. During the war, 80 percent of candy bar production at Curtiss's six Chicago plants went to post exchanges and canteens. Virtually all of its hard candy went to Army C rations. (Associated Press.)

Advertisements for the Cook Chocolate Company's vitamin-enriched Vita-Sert candies appeared in 13 national magazines. Acclaimed as "the vitamin dessert," Vita-Sert capitalized on Americans' newfound craze for multivitamin supplements. Like Bosco and Ovaltine, the popular chocolate drink additives, Vita-Sert appealed to parents' concerns about ensuring proper vitamins and minerals in their children's diets. In 1972, Cook Chocolate Company was renamed World's Finest Chocolate.

Marshall Field & Company started using the name Frango for a chocolate mint candy just after World War II. By the late 1970s, the Frango had become an iconic symbol of the department store, which made some 40,000 pounds of Frango candies annually, in flavors including lemon, rum, and coffee. A newspaper once guessed that Frango mints went home in more tourists' suitcases than any other Chicago candy.

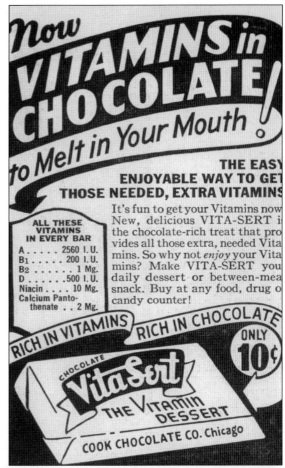

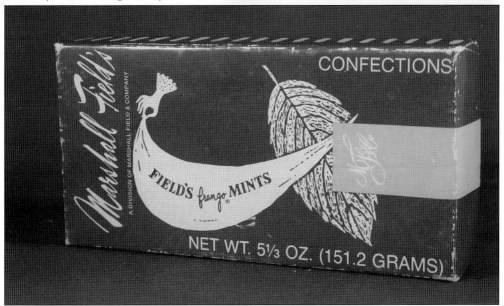

A metal tool pressed into warm chocolate gave Frangos their characteristic top swirl. Frederick & Nelson, Seattle's premiere department store (acquired by Marshall Field's in 1929), claimed that Ray Alden, who ran Frederick's candy kitchen, developed the Frango mint chocolate in 1927. Herbert Knechtel, head of Field's candy department in the 1940s, maintained that he invented the Field's version in 1945 as a way to give Chicagoans good chocolate after years of wartime scarcity.

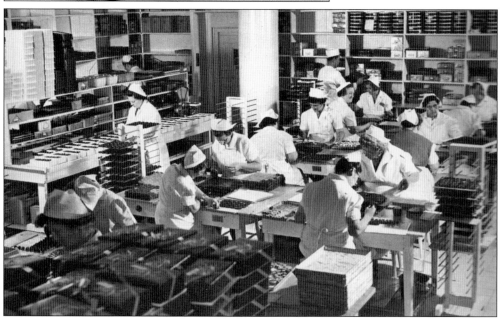

For decades, Marshall Field's workers hand-dipped and packed candies in the workroom on the flagship State Street store's 13th floor. Field's sold both its own store-brand candies and candies from other manufacturers. The Dayton-Hudson Corporation, corporate owner in 1999, incited protest when it moved Frango production to Gertrude Hawk Chocolates in Pennsylvania and closed the Field's candy kitchen. In a goodwill gesture, Macy's returned some Frango production to Chicago in 2009.

"There's Can Do in Candy,"
declared the National Confectioners
Association, encouraging candy breaks
for secretaries and all Americans.
In the years after World War II, the
NCA poured money into a campaign
aimed at convincing Americans of
candy's role as a handy source of quick
energy. Public perception of candy
as the food that had energized the
troops spurred candy consumption to
new highs in the postwar decades.

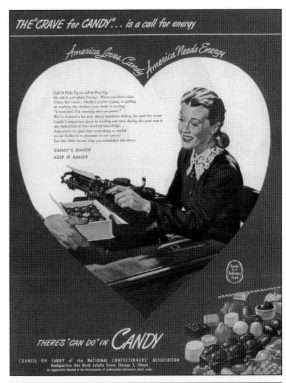

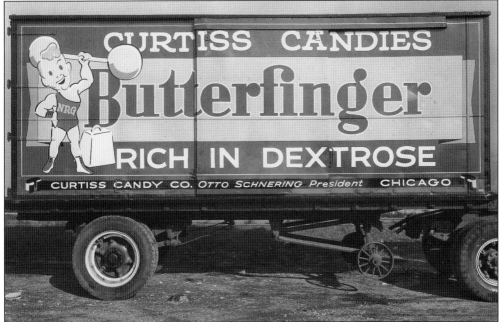

The muscular Curtiss mascot wore a shirt inscribed "N-R-G" to remind customers of the energy-bestowing power of its candies. Curtiss rarely missed an opportunity to promote candy's energy benefits and used the "rich in dextrose" slogan for decades. Scientists had recently announced that dextrose, a type of glucose, was the chief fuel for human bodies, providing powerful ammunition for Otto Schnering's campaign to promote candy as a food, not a luxury.

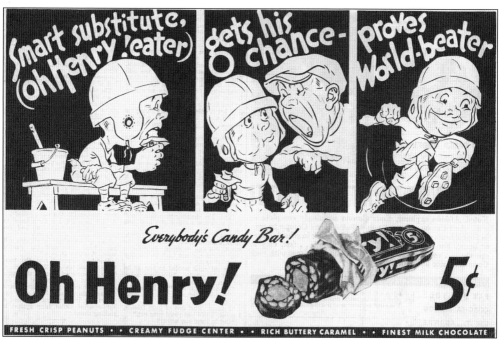

Everyone jumped on the energy
wagon. Snappy cartoons for Oh
Henry! touted the candy's ability to
inspire and energize anyone—from
a hobo to a football star. Williamson
now marketed Oh Henry! as
"everybody's candy bar"—a sharp
contrast to its chic fine chocolate
advertisements of the 1920s.

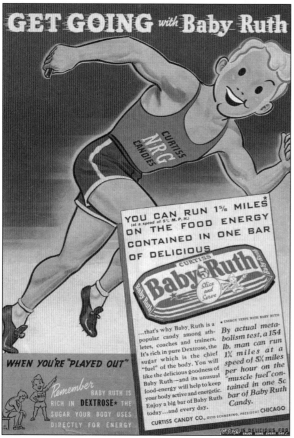

The Curtiss Candy Company
conducted metabolic tests to
determine how far a 154-pound man
could run at a speed of 5.25 miles
per hour on the "muscle fuel" in
one candy bar (answer: just under
two miles). Such advertisements
aimed to counter the image of
candy as a luxurious indulgence.
Probably no candymaker
promoted the energy benefits
of candy more enthusiastically
than Otto Schnering.

A palm tree and ocean view lent an exotic, tropical aura to Curtiss's Coconut Grove bar. However, the Coconut Grove only lasted a short time. Like most new candy bars at this point, it struggled in the face of firm American loyalty to favorite brands. When it came to a coconut candy bar, by the 1940s Americans tended to choose a Mounds bar, which had been around since 1920 (and had been made by Peter Paul since 1929).

Advice on proper barn etiquette decorated the stall of Proud Sally, the cow holding the milk production record at Curtiss Farms near suburban Cary in 1951. Otto Schnering began purchasing land here in the mid-1940s, eventually acquiring nearly 10,000 acres and raising 900 dairy cows and 9,000 hens. The model farm included a sanitary cow barn with air-conditioning and electronically operated fly screens. Otto Schnering insisted, "Every cow on this farm is a lady and should be treated as such." (Wallace Kirkland/Time Life Pictures/Getty Images.)

Otto Schnering (left) reserved his greatest pride, however, for his prized bulls. "The Farm of Champions" earned Curtiss numerous cattle trophies and blue ribbons and propelled the Curtiss Breeding Services into one of the largest, most renowned artificial breeding businesses in the country. After Schnering's death in 1953, most of his land was sold to a housing developer. (Wallace Kirkland/Time Life Pictures/Getty Images.)

Bidders crowded into Kranz's Candy for an auction of the store's elegant Art Nouveau furnishings. Kranz's daughter Florence Kranz kept the store in operation until 1946, giving it a remarkable 78-year run. "Grope for your handkerchief, wipe away a furtive tear," lamented the *Chicago Tribune*, remembering tall glass jars of hard candies, silver salvers embossed "Kranz," and marble tables on which bodies were laid out after the devastating 1903 Iroquois Theater fire.

Dutch Mill Candies splashed its name across bold storefronts, such as this one photographed in 1946. Dutch Mill then operated nearly 50 Chicago-area shops, selling candy, ice cream, and luncheons. Dutch Mill had an appealing "old-world" aura and specialized in Dutch-processed chocolate (chocolate treated with an alkalizing agent), which was said to yield a richer, creamier taste. (Chicago History Museum/ Hedrich-Blessing, HB-09479G.)

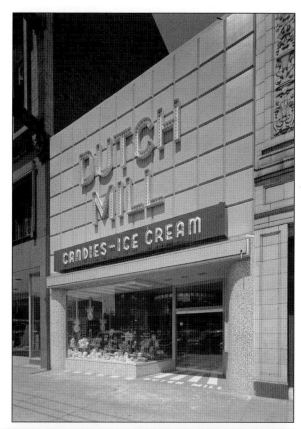

Walter H. Johnson emblazoned the name of its most popular candy bar across its new million-dollar plant at Belmont and Kilbourn Avenues in 1947. The new plant gave Johnson twice the space of its former location on Superior Street. Ironically, Walter H. Johnson might be best remembered today not for Power House, but for its trading cards, especially those packed with Dick Tracy caramels in the 1930s. (Chicago History Museum/ Hedrich-Blessing, HB-10312A.)

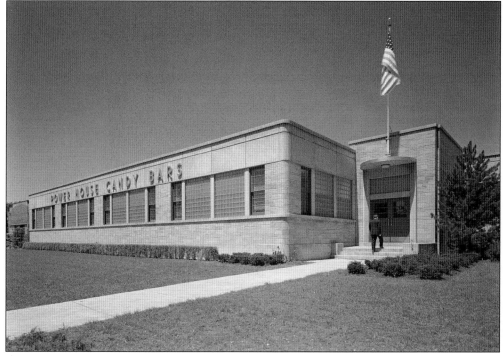

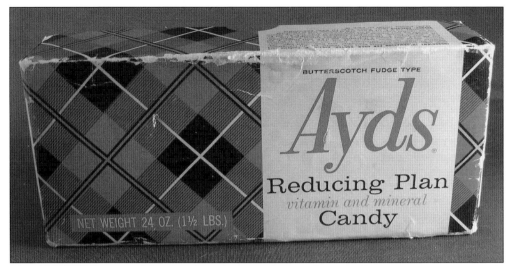

Chicago's Carlay Company developed a vitamin- and mineral-enriched appetite-suppressant candy called Ayds around 1950. Ayds' active ingredient was originally benzocaine, which presumably suppressed the appetite by numbing taste buds. Ayds sold well for several decades, but in the 1980s, public awareness of the disease AIDS, with its phonetically identical name, caused sales to plummet. Despite a change of name (to Diet Ayds), the candy soon vanished.

Brach's made headlines on September 7, 1948, after an electrical spark ignited corn starch, causing a massive explosion on the factory's third floor. The blast killed 11 employees, injured 18 more, and destroyed much of the factory's north side. Fortunately, it occurred prior to the start of the day shift, when 2,400 employees were due to arrive.

Five

KINGS OF THE
CANDY COUNTER
1950s–1960s

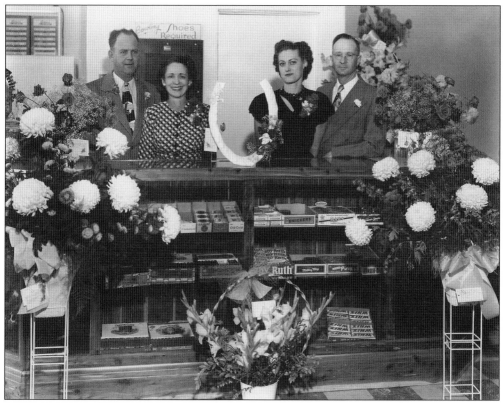

Beaming owners of a new bowling alley in New Mexico inadvertently captured Chicago's dominance in the candy industry in their opening-day snapshot. Every candy displayed in their candy counter had ties to Chicago or Illinois: Wrigley's gum, Snickers, Milky Way, Mars Toasted Almond, Forever Yours, Baby Ruth, Ping, Bit-O-Honey, and Whiz.

Luxurious flowers grace the top of a chic Mrs. Stevens candy tin. Julia Stevens, who launched her candy business after divorcing her first husband, promoted an elegant aura for her candies, although they were priced competitively. By selling three pounds of candy for $1, Stevens stayed solvent, even during the Great Depression. In the 1960s, she sold her retail stores and focused on department stores—eventually accumulating 250 store accounts.

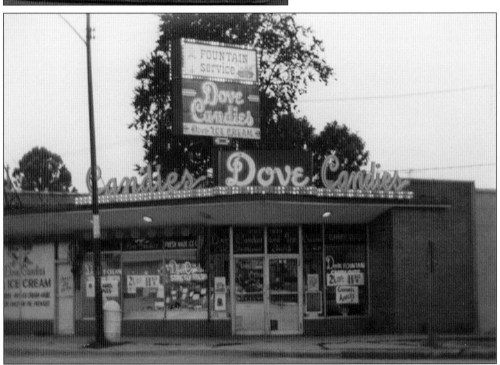

"My Dad had the best candy and ice cream around, and my brother and I were guilty of taking off after the ice cream truck when we heard the bells," said Michael Stefanos, explaining the origin of his father's Dove Bars. Leo Stefanos, who had two Dove Candies shops in 1956, invented a blocky ice cream bar to keep his kids away from other dealers. Mars acquired Dove in 1986 and introduced Dove Chocolates in 1990. (Edward Kwiatkowski.)

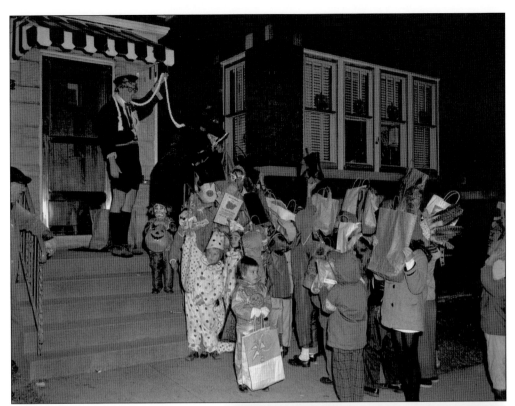

George Motyka, mascot for the Chicago Bears, donned a bear costume while passing out candy on Halloween in 1962. Trick-or-treating was still new, having only recently supplanted pranks and fortune-telling. Many adults still disdained the custom; one Chicago father, quoted in a *Chicago Tribune* column, grumbled, "Why do people put up with these buried threats—you pay me off or I'll wreck your house?"

Mars sold its candies in packages of 24 to make it easy for people to prepare for trick-or-treaters. Chicago candy companies, including Mars, played a critical role in selling the public on Halloween as an occasion for candy consumption. A slew of national marketing campaigns from Chicago confectioners in the 1950s promoted trick-or-treating. In 1920, the custom had not existed; by 1960, it was firmly established as an American holiday tradition.

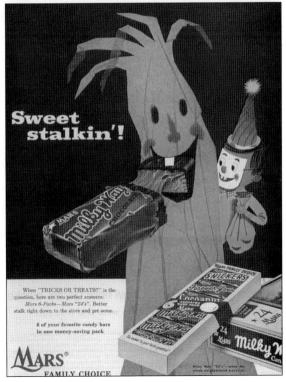

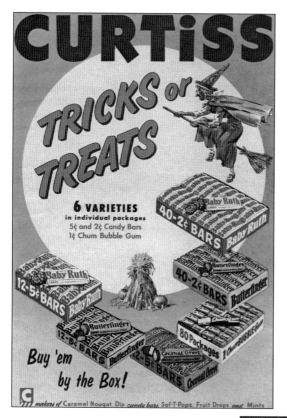

Curtiss made Baby Ruth and Butterfinger bars in both regular 5¢ and miniature 2¢ sizes. The company might have pioneered the diminutive candy bar specially designed for "Tricks or Treats." In 1960, 40-count packs of 2¢ Curtiss candy bars sold for an economical 69¢. Curtiss later took credit for the custom of giving out candy bars (presumably instead of bags of candy or other treats) for Halloween.

Brach's had been promoting candy corn and other fall-themed candies for years. When consumers began bagging up its candies into small sacks to hand out to trick-or-treaters, the company started selling pre-packaged, single-serve packets. "Some super-sanitary little stinkers will accept no dainties that are not in germ proof wrappings," a North Shore letter-writer snorted in the *Chicago Tribune* in 1949.

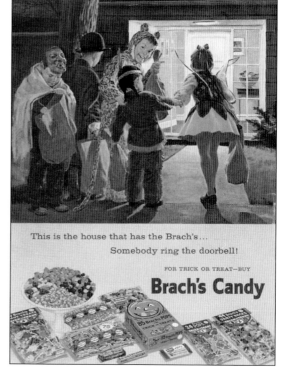

This is the house that has the Brach's...
Somebody ring the doorbell!

FOR TRICK OR TREAT—BUY

Brach's Candy

Kraft, Inc., might have been better known for Velveeta processed cheese and Miracle Whip salad dressing, but its famous cube-shaped caramels gave it a strong confectionery presence. Confectionery fit well with the company, which had a reputation built on dairy products after beginning as a small door-to-door cheese-delivery business in 1903. The company also had candy success with its Jet-Puffed Marshmallows, introduced in 1953.

KRAFT FUDGIES make home _sweet_ home because they taste so wonderful. Big deal for Trick or Treat — 42 in every bag — each one wrapped! Pick Chocolate or Vanilla.

Like many candies that have been discontinued, Kraft's chocolate caramel Fudgies, in their distinctive gold wrappers, have inspired nostalgic fans to plead for their return. "I think it was its simplicity and the sheer ecstasy it delivered, you would always have to eat another. My Aunt would treat us with these in the sixties, but she had to hide [them] and parcel them out," wrote Michael Dale on the website Brandland USA in 2009.

A glass bottle still holds cinnamon hearts from the venerable Farley Candy Company. The firm was born in 1891 when several Farley family members joined their separate confectionery companies together. It remained family-operated through the 1950s. By the early 2000s, following a string of mergers and acquisitions, the name became part of Minnesota-based Farley's & Sathers, which is now the country's largest non-chocolate candy company.

Although he was a strong-minded businessman with little patience for sloppiness, Henry Blommer of the Blommer Chocolate Company also had boundless energy and a flair for storytelling that made him an ideal ambassador for the industry. Pictured here with his wife Viola, Blommer cochaired the 78th annual National Confectioners Association Convention in Chicago in 1961. He actively participated in the NCA, regularly spoke on panels discussing the chocolate business, and served as an advisor on national cocoa activities. (Blommer Chocolate Company.)

President and chairman of the board William L. Kruppenbacher (second from right), the half-brother of Frank Mars's first wife, Ethel Mars, joined other executives to examine new case packing and sealing machines installed during a $4.1-million expansion of Mars' Chicago plant in 1959. The company had been slow to innovate after Frank Mars's death in 1934. The lack of advancement infuriated Frank's son Forrest Mars, who wrested control of the company five years later.

Philip K. "P.K." Wrigley (son of William Wrigley Jr.) posed with his 24-year-old son William in 1957. Just four years after this photograph, William stepped in as third head of the company when his father passed away. William Wrigley guided the company through the 1990s, encouraging heavier investment in research and the expansion into new lines that included bubble gum, sugarless gum, and other innovations.

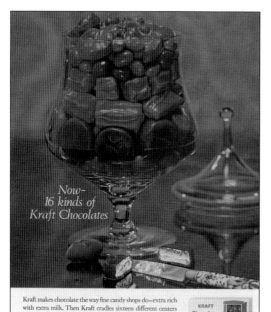

Now–
16 kinds of
Kraft Chocolates

Kraft makes chocolate the way fine candy shops do—extra rich with extra milk. Then Kraft cradles sixteen different centers in this richer and smoother chocolate. The result...
chocolates like you buy in candy shops —now at your store.

KRAFT Chocolates
The fancy candies come from Kraft

In the mid-20th century, Kraft offered a line of popularly priced fine chocolates. Despite strong name recognition and the use of "extra milk," the chocolates lasted a relatively short time. Kraft would not reemerge as a leader in chocolates until it acquired British candymaker Cadbury for $18.9 billion in 2010, a purchase that made Kraft the world's leading company in candies and chocolates.

Brach's capitalized on the drawbacks of chocolate in summer by promoting its candies as ideal for the season. In the days before universal air-conditioning, few other candy companies could compete with Brach's powerhouse combination of heat-stability, freshness (high sales meant consistent restocking), and convenience (Brach's candies could be purchased by the bag or in bulk).

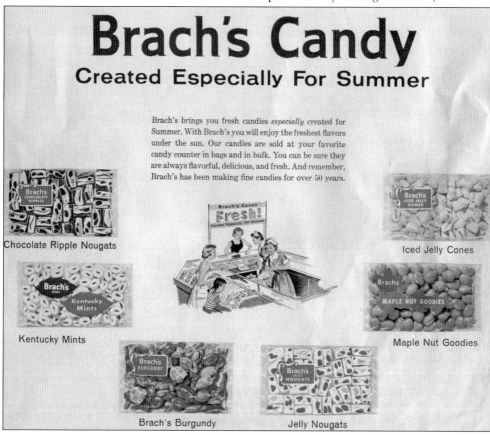

Brach's Candy
Created Especially For Summer

Brach's brings you fresh candies *especially* created for Summer. With Brach's you will enjoy the freshest flavors under the sun. Our candies are sold at your favorite candy counter in bags and in bulk. You can be sure they are always flavorful, delicious, and fresh. And remember, Brach's has been making fine candies for over 50 years.

Chocolate Ripple Nougats

Kentucky Mints

Brach's Burgundy

Jelly Nougats

Iced Jelly Cones

Maple Nut Goodies

Pres. Frank V. Brach (left) shows off a Brach's Pick-A-Mix self-serve kiosk. Introduced in 1958, the stands allowed customers to scoop their own mix of candies priced by the pound. The displacing of the corner candy store by supermarkets was a major industry shift in the 20th century. The Pick-A-Mix concept took advantage of this revolution, bringing old-fashioned penny candy–style bulk buying into the new shopping environment.

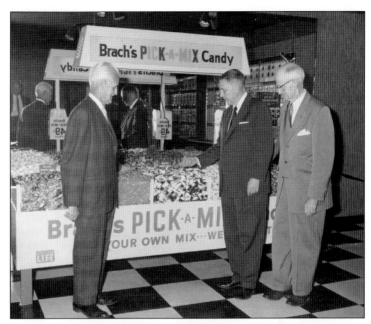

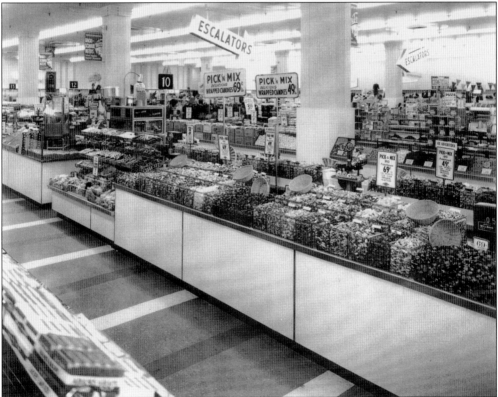

The F.W. Woolworth Company picked up the idea of customer-mixed bulk candy for its chain of five-and-dime stores. At the candy department of this Woolworth store in 1963, customers could choose candy varieties on their own and mix them together at prices ranging from 49¢ to 69¢ per pound.

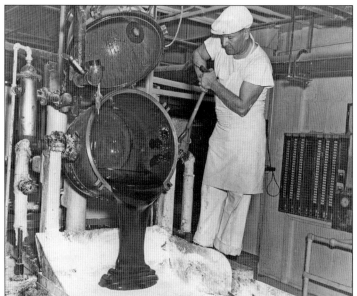

A Curtiss worker pours Butterfinger syrup from the vacuum cooker onto a cold slab for cooling. In 1951, the process of making Butterfingers started with cooking batches of the sugar, milk, molasses, and peanut butter ingredients in giant cookers like the one pictured. (Nestlé and the Chicago History Museum/006293.)

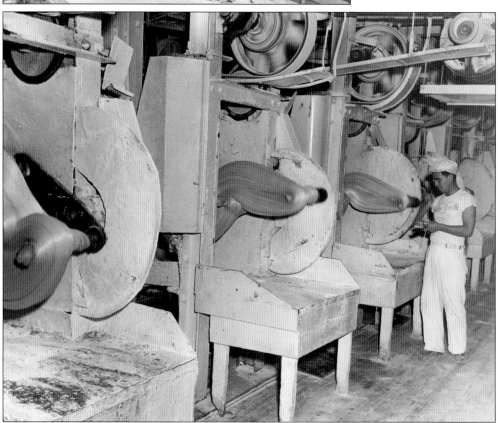

Multiple pulling machines rotated, stretching the Butterfinger candy mixture out and then twisting it together over and over. While pulling is typically associated with making taffy, the same aerating process helped give Butterfinger its signature texture and flaky, crispy layers. (Nestlé and the Chicago History Museum/066287.)

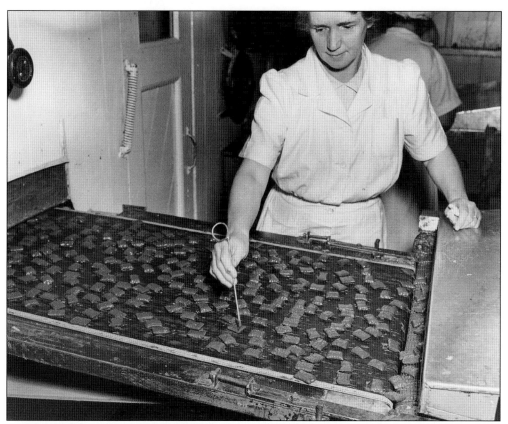

A Curtiss worker uses a thin metal rod to separate Butterfinger chips from each other as they emerge from the enrobing machine. Now wrapped in their chocolate coats, the candy chips move into the cooling tunnel. (Nestlé and the Chicago History Museum/006296.)

Sharp-shooting comic strip detective Dick Tracy was riding a crest of popularity when Chicago's Schutter Candy Company made its Dick Tracy bar in the 1950s. At various times, Schutter also made the Jiminy Cricket bar, Old Nick (a Baby Ruth–like peanut and nougat bar), and Bit-O-Honey. (Richard Saunders, candywrapperarchive.com.)

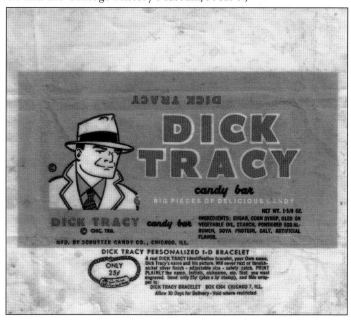

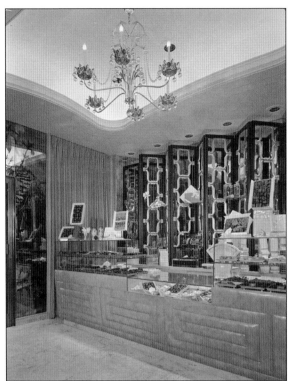

Chandeliers and mirrors gave a chic look to an Andes Candies store in 1950. Founder Andrew Kanelos initially used "Andy's Candies" but changed it after discovering that men disliked buying candy boxes bearing another man's name. The company eventually expanded to include 150 stores. Andrew's son George took the company's thin Crème de Menthe mint, introduced in 1950, national. Fannie May gobbled up the company in the 1960s. (Chicago History Museum/Hedrich-Blessing, HB-13407-B.)

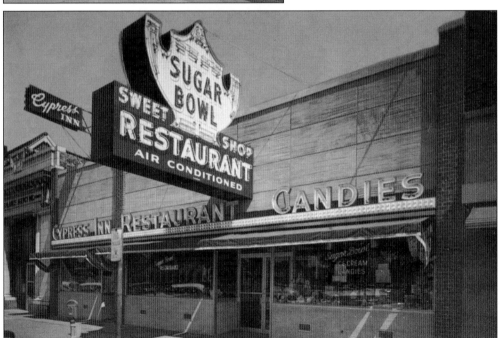

An oversized neon sugar bowl lit up the Sugar Bowl in Des Plaines for decades. Opened in 1921, the family-owned restaurant, candy shop, and soda fountain sold its own hand-dipped chocolates and homemade ice cream and was a favorite hangout for teens and young couples on dates. Its candy kitchen had a turn in the spotlight during the filming of a Brach's commercial in 1986.

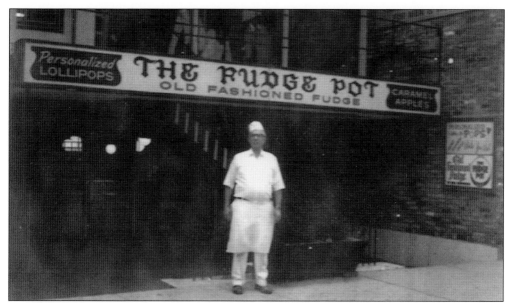

Jim Dattalo, seen here, opened The Fudge Pot, located on Wells Street, in 1963. He learned the craft from his uncle, Tom Dattalo, who was the first employee Frank Mars hired and who eventually became Mars' chief experimental candymaker. Traditionally, the bulk of all candy sales have come from large manufacturers like Mars, but small operations like The Fudge Pot outnumber them. In 1954, more than 90 percent of candymaking businesses employed fewer than 100 people. (David Dattalo.)

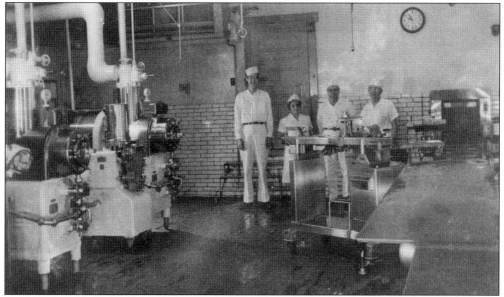

Flat, stainless steel tables provided the surface on which workers at the Naperville Creamery poured hot butter toffee for the creamery's seasonal English toffee specialty. Walter Fredenhagen, cofounder of the Prince Castle and later Cock Robin Ice Cream Companies, developed the toffee in his kitchen in the 1930s to give as thank-you gifts, but people begged him to sell it at his ice cream stores. The toffee was, and still is, only available in November and December. (Fredenhagen family.)

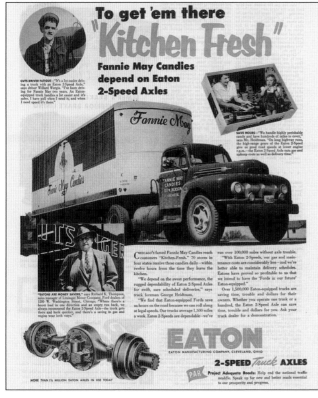

The Fannie May retail store in suburban LaGrange opened in a location directly across from the village's railroad station. Ninety percent of Fannie May's business was done through stores (the remaining was wholesale to companies), so locations were carefully chosen. Candy chains preferred locations where shoppers and workers regularly passed.

State-of-the-art trucking equipment was key to Fannie May's reputation. By the late 1950s, the company delivered candy to 70 stores in four states each day, usually within 12 hours of leaving the factory. "Some might think, 'no preservatives? My God, it will spoil,'" said John Hughes, Fannie May's chief executive officer, in 1986. "But the truth is that we'll take it off the shelf before it can spoil."

Dummy candy boxes once used as displays in Fannie May stores show some of Fannie May's most popular mint candies. The cursive Fannie May "autograph" and the glossy white boxes, along with the stores' signature red-and-white awnings and white woven basket displays, were ingenious pieces of marketing, evoking the nostalgic aura of a grandmother's kitchen.

Tootsie Roll blew into the Windy City in 1966 when the Sweets Company of America opened its first Midwest facility in southwest Chicago. Soon, company management relocated to Chicago as well, and the name was changed to Tootsie Roll Industries. It was a time of rapid expansion for Tootsie Roll, whose net earnings nearly tripled in the early 1960s. The Chicago factory would become the company's main plant, with a size of more than two million square feet.

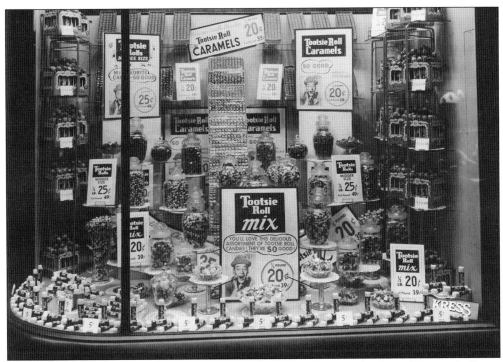

A lavish showing of Tootsie Roll products decorates a Kress Store window in this typical shop window display. Austrian immigrant Leo Hirschfeld of Brooklyn invented the chewy chocolate candy in 1894, naming it for his daughter Clara "Tootsie" Hirschfeld. To keep each Tootsie Roll clean and sanitary, he rolled it in a distinctive brown, white, and red wrapping that reportedly made the treat the first individually wrapped penny candy. (Tootsie Roll Industries.)

William Rubin, president of the Sweets Company of America (maker of Tootsie Rolls), did not have to look far to find a fresh-faced girl for this 1950 *Life* magazine advertisement. It was his daughter Ellen, then just 18 years old. By 1978, she would occupy her father's former job at the helm of Tootsie Roll, becoming only the second woman ever named president of a company on the New York Stock Exchange. (Tootsie Roll Industries.)

Ellen Gordon (pictured) and her husband, Melvin J. Gordon, have guided Tootsie Roll through more than five decades of careful expansion. Melvin Gordon took the helm of Tootsie Roll in 1962 after his father-in-law's death, overseeing the company's move to Chicago in 1966. The Gordons grew the company steadily, promoting expansion by acquiring such classic brands as Junior Mints, Charleston Chew, and Sugar Babies and maintaining efficient technology to maximize production.

One major factor behind Tootsie Roll's longevity (besides taste) was its nonperishable quality. As this advertisement notes, the candy could resist even extreme weather. The same qualities that made the candy popular for summer outings also made it popular with the military. Tootsie Rolls have been included in military rations since World War II.

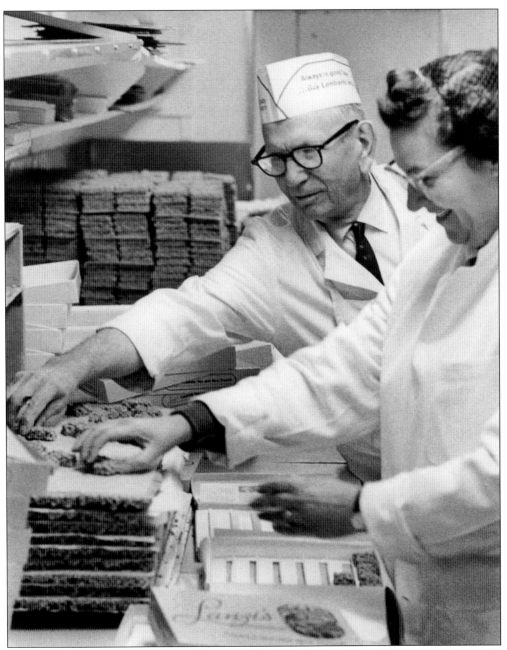

Elmo Lanzi (left) helps pack boxes with Cashew Nut and Rice Crunch, his most popular candy. Lanzi had retired from the candy business he founded in 1920 when he whipped up the first batch of the crunchy, cashew-studded, butterscotch-flavored treat for a neighborhood picnic in 1959. Its popularity forced him to reopen his business. "My mother had to ration the box," wrote one former fan on the food website Chowhound. "I still dream about them, they were that good," said another, 25 years after eating the candy for the last time. Lanzi himself invented the world's first chocolate peanut cluster machine in 1928 and designed or built much of the machinery used in his plant. (Michael Lahey.)

A waterfall of popcorn and peanuts pours off the conveyor belt at the Cracker Jack plant in suburban Northbrook. The giant food conglomerate Borden, Inc., moved production to this plant in 1964 after acquiring Cracker Jack in a successful bidding war against Frito-Lay. The 25,000-square-foot plant produced 19 tons of Cracker Jack every day. The plant closed after Borden sold the brand to Frito-Lay in 1997.

Reynolds Metal Company displayed sheets of gleaming Cracker Jack labels in this advertisement for its new technology: high-speed printing on aluminum foil. Cracker Jack was among the first to use Reynolds' new development, which first made foil packaging economical. The labels were not only eye-catching—they also created an airtight seal, ensuring the crispy freshness that remained key to Cracker Jack's popularity.

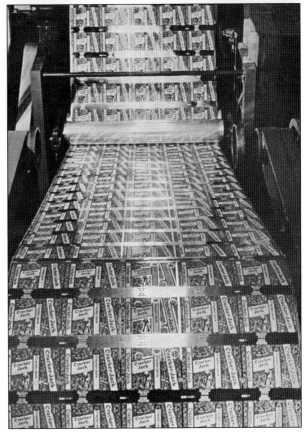

Forklifts carry boxes of malted milk balls through the cavernous Leaf warehouse in 1969. At the time, Leaf was probably the world's largest producer of malted milk balls, making them in more than 50 different packages. The Chicago plant alone produced 30 million malted milk balls daily. In addition to Whoppers, Leaf's famous brands included Rain-Blo gum and Sixlets chocolate candies. (Chicago History Museum/Hedrich-Blessing, HB-32316A.)

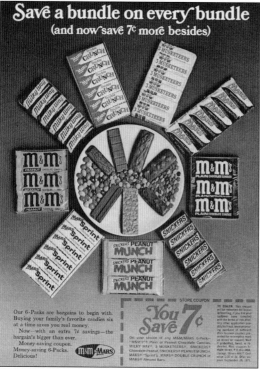

By the late 1960s, the Mars line-up had expanded to include Double Crunch, Munch, and Sprint bars. By this time, Mars had moved its headquarters to New Jersey, but the Chicago factory remained in operation, still churning out longtime favorites.

Six

NEW CHALLENGES, NEW DIRECTIONS
1970s–1980s

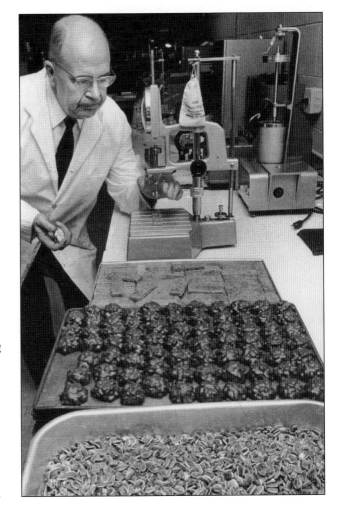

Herbert Knechtel used a special machine to test candies for hardness at his Skokie, Illinois, laboratory. After leaving Marshall Field's candy kitchen, Knechtel opened the country's first confectionery industry consulting firm, helping companies develop, produce, and engineer equipment for candy. "Herb was to the candy industry what Henry Ford was to the auto industry. He was known throughout the world," said former employee Sandy Welchli. Knechtel Research Sciences is currently the world's largest confectionery consultant.

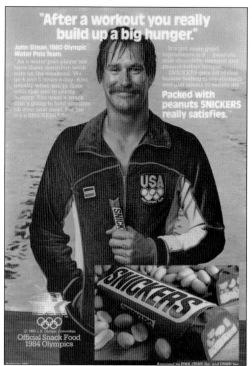

Mars paid $5 million to have Snickers declared the official snack food of the 1984 Olympics, leading to advertisements such as this one featuring John Siman of the United States water polo team. This promotional association of candy with athleticism continued the long-running effort of candymakers to position candy as a quick-energy, fatigue-relieving food.

An airline hostess served Lanzi's Cashew Nut & Rice Crunch to founder Elmo Lanzi and then owner Arlen Gould in the era when American Airlines served the candy in first class. After trying some on a flight in 1977, advice columnist Abigail Van Buren ("Dear Abby") wrote the company to order two dozen boxes. "I don't know whether to kiss you or kill you! You have absolutely destroyed my diet," she joked. (Michael Lahey.)

Aristotelis "Telly" Savalas frequently sucked on a Tootsie Pop while playing the title role in the 1970s television crime drama *Kojak*. Costar Kevin Dobson reportedly explained the origin this way: "[We're] in the office and we're about to do the scene, [Savalas] said, 'I need something, you know?' And here's a guy standing over there with the Tootsie Pop sticking out of his shirt." Savalas stuck the pop in his mouth and an iconic television image was born. (Photoshot/Getty Images.)

Anyone passing the Willy Wonka Candy Company plant (pictured in 2008) in suburban Itasca, Illinois, might be forgiven for feeling disappointed to find a plain industrial building rather than the magnificent, eccentric factory depicted in movies based on Roald Dahl's book *Charlie and the Chocolate Factory*. Nestlé purchased the Willy Wonka candy brands in 1988 and continues to make them here. (Erik Lykins.)

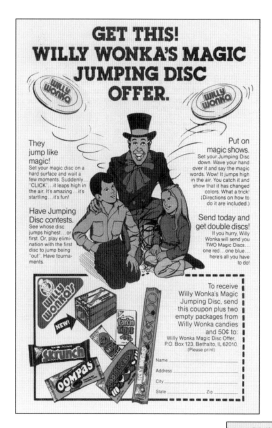

The drawings at lower left on this 1970s advertisement show some early Willy Wonka candies, including Skrunch, Oompas, and Wacky Wafers. Breaker Confections (a subsidiary of Quaker Oats that was later renamed the Willy Wonka Candy Company) developed the candies as merchandising tie-ins for the 1971 movie *Willy Wonka & the Chocolate Factory*. Some products, such as Everlasting Gobstoppers, originated in the book and film. Others were either acquired or created for the brand.

Henry "Hank" Aaron was avidly pursuing Babe Ruth's record for career home runs in Major League Baseball when he began promoting Oh Henry!, which had been sold to the Ward Candy Company of New York in 1971. It was a natural fit, since fans sometimes tossed Oh Henry! bars on the field when Aaron scored. Some believed the bar was named for Aaron; actually, Oh Henry! hit the market 14 years before Aaron was born.

Baseball slugger Reggie Jackson got his own candy bar when Curtiss (then owned by Standard Brands but still operating from Chicago) created a new bar in his honor in 1977. When Jackson stepped to the plate in the 1978 New York Yankees home opener, thousands of Reggie bars cascaded onto the field. Reggie never sold well outside New York City, however, and in 1982, Curtiss quietly retired it.

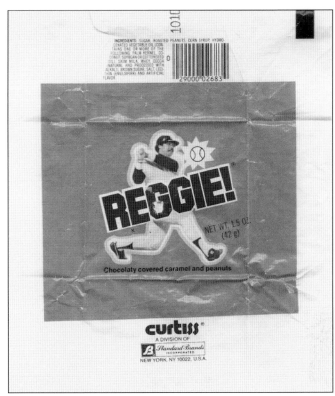

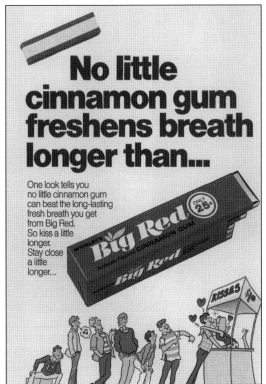

This memorable advertising campaign playfully emphasized Big Red gum's breath-freshening power, which let chewers kiss "a little longer." Big Red marked a new direction for Wrigley, which had not focused much on trendiness or new flavors since Doublemint appeared in 1914. Along with Freedent (1975), Big Red brought Wrigley into new fields, which it quickly dominated. When Big Red debuted in 1976, Dentyne was the top cinnamon gum in the United States; by 1987, Big Red was number one.

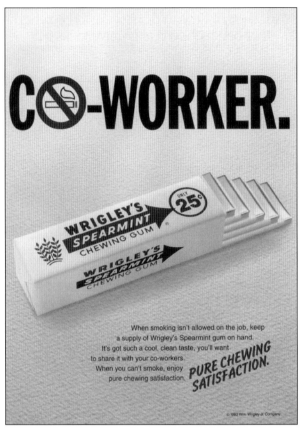

Wrigley hit another advertising home run with its "pure chewing satisfaction" campaign. These advertisements encouraged gum-chewing as an alternative to smoking, using phrases such as "Co-Worker," "House Guest," and "Frequent Flyer" with a red slashed circle (the international "no smoking" sign) through one letter. The campaign tackled the emerging backlash against smoking in public while echoing earlier campaigns by suggesting people could use gum to navigate tricky social situations.

The Curtiss factory was a longtime landmark on the Chicago River. "The aroma is so sweet you can almost taste the Baby Ruth," reported the *Chicago Tribune* prior to the building's demolition in 1970. By that time, it was an anachronism, a vestige of river commerce that dated back to era of lumber mills and grain warehouses. Curtiss built a new factory in Franklin Park in 1966, where Nestlé continues to make Butterfinger and Baby Ruth today.

Although Whoppers malted milk balls were a longtime Leaf specialty, Milk Duds were new to the company at the time of this 1987 advertisement. Leaf had recently acquired Milk Duds, along with such famous candy bars as Payday, Zero, and Heath, making it one of the world's top 10 confectionery companies. Like Leaf, many candy companies experienced growth in the 1960s and 1970s by acquiring other well-established candy brands.

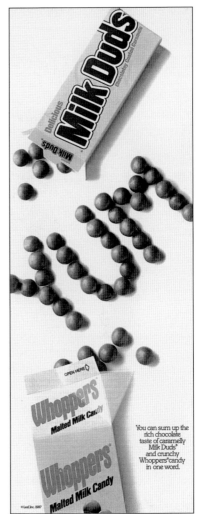

You can sum up the rich chocolate taste of caramelly Milk Duds® and crunchy Whoppers®candy in one word.

Every autumn, Peter Vasilakos hand-dipped more than 10,000 caramel apples for the Ideal Candy Company at 3311 North Clark Street. Ideal, which specialized in hand-dipped chocolate candies and classic ice cream creations, had been a popular neighborhood landmark since opening in 1937. It remained family-run until it closed in 1986.

Railroad tracks for the Dunning line of the Chicago, Milwaukee, St. Paul & Pacific Railroad (The Milwaukee Road) ran alongside the Kimbell Candy Company on Belmont Avenue. Rail lines frequently popped up near candy factories, easing delivery of bulky agricultural products such as sugar and corn syrup. Kimbell is best remembered for its coconut candies made in multiple shapes and flavors. (Tom Burke and Milwaukee Road Historical Society.)

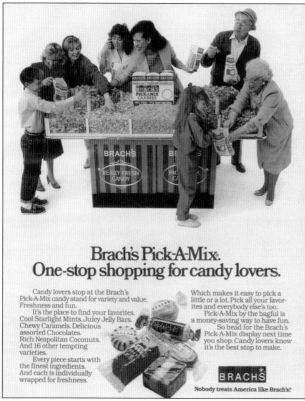

Brach's and its now iconic Pick-A-Mix still dominated the general line and bulk candy market in the 1980s, but the company's fortunes would soon decline. In 1987, American Home Products sold Brach's to the Swiss firm Jacobs Suchard. Suchard and Brach's leadership clashed over conflicting goals and management styles. Suchard scaled back Brach's line and stumbled in negotiating key differences between American and European candy markets. Brach's sales slumped.

114

Seven

SWEET HORIZONS
1990s AND BEYOND

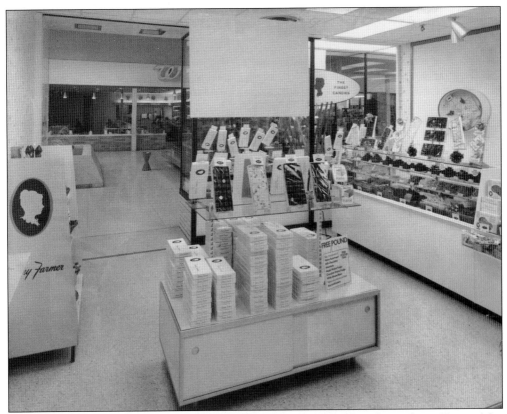

Clean and spotlessly white, Fanny Farmer candy stores looked strikingly similar to Fannie May shops. The Archibald Candy Corporation acquired Fanny Farmer in 1992 as a northeastern sister to Fannie May. Named in honor of cooking guru Fannie Merritt Farmer, Fanny Farmer operated 200 retail stores at the time. Alpine Confections acquired both brands in 2003, and the name Fanny Farmer quietly disappeared.

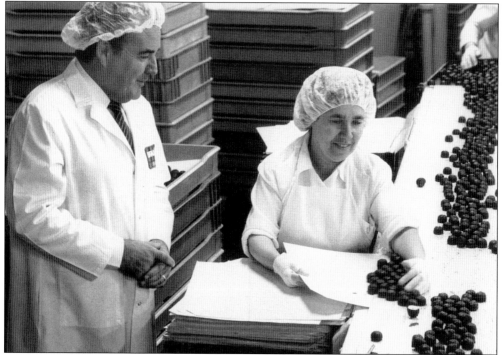

Peter Rogers, pictured at left while inspecting chocolate-covered cherries, took the helm at Brach's in 1990—the company's third CEO in three years. Rogers attempted to turn the company around and rebuild its product line, but Brach's troubles mounted. The company dropped to 50 percent capacity and began to post a series of massive losses. Brach would not announce an operating profit again until 1994.

Neighbors sometimes called the Peerless Confection Co. building at Diversey Parkway and Lakewood Avenue the "pick-up stick building" for the Angelo Testa sculpture on its otherwise stark walls. Many were shocked when Peerless announced it was closing in 2007, citing declining hard candy consumption and pressure to switch to offshore production. The building was demolished in 2008. (Mark Susina.)

Peerless made nearly 300 varieties of hard candy, including popular filled confections long sold under the Peerless Maid name ("No Candy Made Like Peerless Maid"). Its other classic best sellers included peppermints, old-fashioned cut rock, root beer barrels, and black walnut chips. After opening in 1924, Peerless churned out hard candies for 83 years.

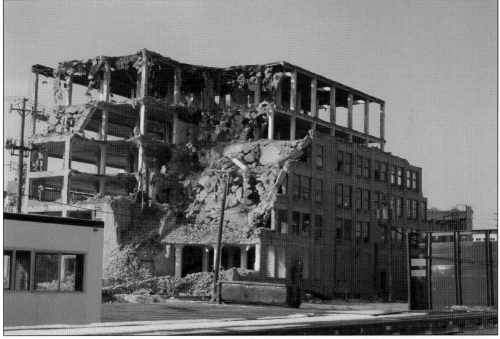

Chocolate and pecans still seemed to waft from the empty floors of the Fannie May candy factory building as it came down in 2007. The 500,000-square-foot factory on Jackson Boulevard closed as part of Fannie May's 2004 bankruptcy. New owner Alpine Confections moved production to Ohio. "Chicago without Fannie May is as unthinkable as winter without snow," said the *Chicago Tribune*. (Ken Smith.)

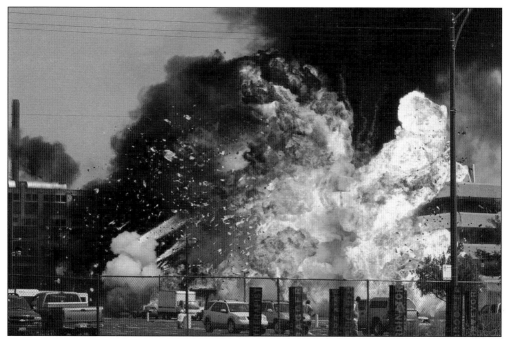

"It was very noisy with a tremendously hot fireball that could be felt from across Cicero," one local observer reported to HollywoodChicago.com during filming of the Batman movie *The Dark Knight* in August 2007. One of the former Brach administrative buildings—standing in as Gotham City Hospital—was imploded for the action movie. For many Chicagoans, it was a sorrowful end to a part of the longtime landmark. (Associated Press.)

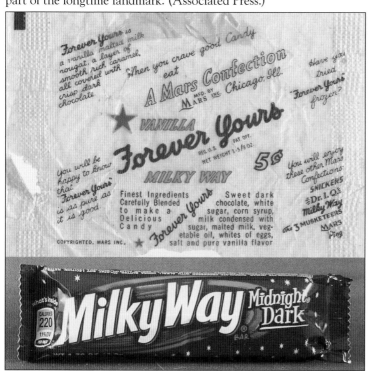

Between 1936 and 1979, Mars sold a dark chocolate–covered bar called Forever Yours. In 1989, the company introduced a remarkably similar bar called Milky Way Dark and later Milky Way Midnight Dark. The modern name reflects the current trend of candies launched as spin-offs, making "new" candies seem fresh and innovative but still familiar.

Tootsie Roll's growth in the late 20th century rested on creative additions to its established line as well as careful acquisition of other favorite brands. Some of the famous brands pictured that are now owned by Tootsie Roll include Charms, Blow Pop, Dots, and Andes. Others candies not pictured include Junior Mints, Cella's, and Charleston Chew.

It felt like a royal wedding in 2008 when Wrigley and Mars united. Here, William Wrigley Jr. II, executive chairman of the William Wrigley Jr. Company, and William Perez (right), Wrigley president and CEO, answer questions about the recent announcement that the chewing gum giant would merge with Mars. Following the $23-billion transaction, Wrigley became a separate, stand-alone subsidiary of Mars. (Scott Olson/Getty Images.)

Marlene Fortney prepares a customer's order at the newly reopened Fannie May store in suburban Oak Lawn in October 2004. Fans of Trinidads and Pixies rejoiced when Utah-based Alpine Confections, Inc., announced it would reopen 47 Fannie May retail stores. However, Fannie May's stay with Alpine was brief; in 2006, Alpine sold Fannie May to Internet retailer 1-800-Flowers. com. (Tim Boyle/Getty Images.)

Day-to-day operations at The Fudge Pot are now overseen by David Dattalo, whose father, James, founded the shop. The store makes its candies on the spot in a storefront location where passersby can watch. In addition to 10 flavors of fudge, the store makes personalized lollipops and some 1,000 different molded chocolate items. (Bill Bishoff.)

Millions of school bands, clubs, and sports teams have raised money selling World's Finest Chocolate bars. Edmond Opler Sr. began offering candy bars for use in fundraisers in 1949, ten years after he launched the company (then known as the Cook Chocolate Co.). In 1999, at the time of its 50th anniversary, the company estimated that more than five billion fundraising bars had been sold.

World's Finest Chocolate smashed a Guinness World Record in 2011 when it unveiled a 12,229-pound bar of chocolate, beating the previous record for world's largest chocolate bar by more than a ton. At three feet tall and 21 feet long, the behemoth required a custom-built mold to achieve the signature WFC shape. It hit the road for a 60-city national tour to encourage portion control and moderation in eating. (World's Finest Chocolate.)

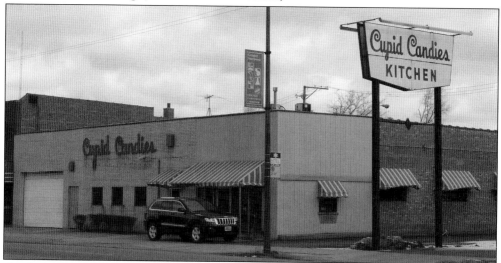

Greek immigrant Paul Stefanos (part of the same family that started Dove Candies) once attributed his longevity to a habit of eating a quarter-pound of candy daily. He founded Cupid Candies in 1936, eventually opening 12 Cupid stores, of which three remain, including the manufacturing plant store at Seventy-sixth Street and Western Avenue, seen here. Even those who do not know the name often know Cupid Candies; it develops private label candies for companies such as Crate & Barrel and Figi's.

The Chicago factory that was the birthplace of Snickers (in 1930) and 3 Musketeers (in 1932) remains in operation today. Mars' oldest continuously operating facility produces these bars as well as other favorites, such as Dove chocolates and Munch candy bars. (Elizabeth Amann.)

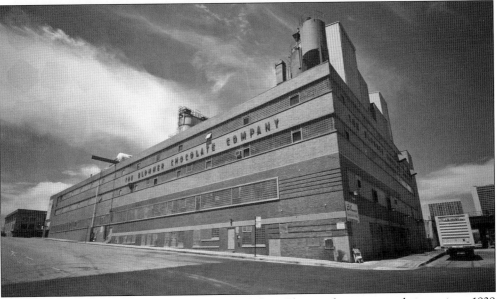

The Blommer Chocolate Company has expanded its Chicago factory several times since 1939 but remains in the same location near the Chicago River. Blommer now accounts for nearly 50 percent of the cocoa beans processed in the United States. Together with plants in Pennsylvania and California, it produces 500 million pounds of chocolate per year, selling chocolate to both small and large establishments. The company maintains more than 400 recipes specialized for different customers. (Carl Lukasewich.)

Second- and third-generation Blommer family members gathered for a group portrait to commemorate the leadership that has emerged since Henry Blommer's death in 1992. The family hit a few bumps, including a bitterly painful dispute that arose when disgruntled family members sold their shares to Cargill, Inc., on the heels of Henry's death. However, the company regained its footing and solidified its status as the largest cocoa processor and ingredient supplier in North America. (Blommer Chocolate Company.)

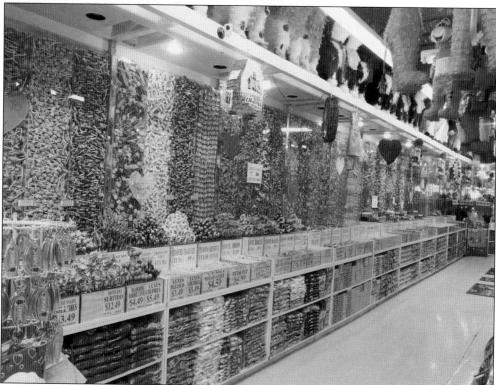

The walls of a Dulcelandia store, seen here in 2012, overflow with bins of Mexican candies and chocolates, including spicy chicken-shaped lollipops, tamarind-chile hard candies, and peanut marzipan. "I remember seeing people with tears in their eyes," said Julio Rodriguez, son of company founders Eduardo and Evelia Rodriguez, recalling the first store's 1995 opening during an interview with *Candy Industry* magazine. "When you see a piece of your childhood, you're just blown away by it." Dulcelandia now has seven Chicago-area locations. (Elizabeth Amann.)

Vosges Haut-Chocolat bars come in exotic flavors spiced with chilies, cinnamon, ginger, and wasabi. Katrina Markoff founded Vosges in Chicago in 1998 with the mission of enabling consumers to travel the world through chocolate. *Food & Wine* magazine called her "THE innovator in chocolate to lead the U.S. through the next 30 years." Connoisseurs clamor for her most popular treat: Mo's Bacon Bar, which blends smoked bacon and sea salt with milk chocolate.

Terese Lang McDonald—a self-proclaimed candy maniac—opened the first Candyality shop on Southport Avenue in 2007. The colorful shop offers vintage and modern kid-friendly candies with an innovative twist. McDonald and her staffers read customers' purchases, whether sugary, sour, fluffy, chewy, colorful, or crunchy, for the personality clues they reveal. By 2011, Candyality had three locations. (Terese Lang McDonald and Bonnie Bandarski.)

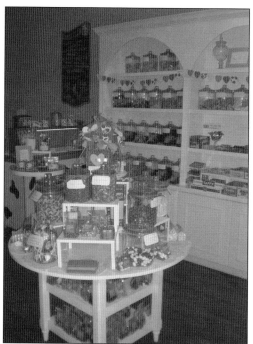

Ask Amy Hansen the latest trend in Chicago candy and she can simply point to her upscale candy store, Amy's Candy Bar, which opened in 2011. Well-versed in artisan confectionery after training at Chicago's French Pastry School, Hansen makes her own smoothly melting caramels and almond-studded nougats. Her store also stocks nostalgic candies and imported sweets from across the world, catering to the diversity that characterizes candy lovers today. (Amy Hansen.)

Despite the sour economy, life was sweet at the 13th annual All-Candy Expo in Chicago's McCormick Place convention center in 2009. Some 450 companies gathered for the annual industry-only event (later renamed the Sweets and Snacks Expo), sponsored by the National Confectioners Association, where some 2,000 new treats debuted. As host of the exposition, Chicago remains a major venue for confectioners and retailers alike to learn about the latest trends and innovations in the candy business. (National Confectioners Association.)

BIBLIOGRAPHY

Abbott, Henry G. *A Historical Sketch of the Confectionery Trade of Chicago*. Chicago: Jobbing Confectioners Association, 1905.

Austin, Alma H. *The Romance of Candy*. New York: Harper and Brothers, 1938.

Brenner, Joël Glenn. *The Emperors of Chocolate: Inside the Secret World of Hershey & Mars*. New York: Random House, 1999.

Broekel, Ray. *The Chocolate Chronicles*. Radnor, PA: Wallace Homestead Book Company, 1985.

———. *The Great American Candy Bar Book*. New York: Houghton Mifflin, 1982.

Cooper, Gail. "Love, War, and Chocolate: Gender and the American Candy Industry, 1890–1930." In *His and Hers: Gender, Consumption and Technology*, edited by Roger Horowitz and Arwen Mohun, 67–94. Charlottesville, VA: University of Virginia Press, 1998.

Cronon, William. *Nature's Metropolis: Chicago and the Great West*. New York: W.W. Norton & Company, 1991.

Dusselier, Jane. "Bonbons, Lemon Drops, and Oh Henry! Bars: Candy, Consumer Culture, and the Construction of Gender, 1890–1920." In *Kitchen Culture in America*, edited by Sherrie A. Inness, 13–49. Philadelphia: University of Pennsylvania Press, 2001.

Gott, Philip P., and L.F. Van Houten. *All About Candy and Chocolate*. Chicago: National Confectioners' Association of the United States, 1958.

Jaramillo, Alex. *Cracker Jack Prizes*. New York: Abbeville Press, 1989.

Kimmerle, Beth. *Candy: The Sweet History*. Portland, OR: Collector's Press, 2003.

———. *Blommer: An American Chocolate Legacy*. Chicago: Blommer Chocolate Company, 2010.

Smith, Andrew F. *Popped Culture: A Social History of Popcorn in America*. Columbia, SC: University of South Carolina Press, 1999.

Weaver, William Woys. *Culinary Ephemera: An Illustrated History*. Berkeley, CA: University of California Press, 2010.

Woloson, Wendy A. *Refined Tastes: Sugar, Confectionery, and Consumers in Nineteenth-Century America*. Baltimore: The Johns Hopkins University Press, 2002.

Writers' Program of the Works Projects Administration in the State of Illinois. *Chicago's Candy Kettle*. Chicago: Board of Education, Division of Department Reports, 1941.

DISCOVER THOUSANDS OF LOCAL HISTORY BOOKS
FEATURING MILLIONS OF VINTAGE IMAGES

Arcadia Publishing, the leading local history publisher in the United States, is committed to making history accessible and meaningful through publishing books that celebrate and preserve the heritage of America's people and places.

Find more books like this at
www.arcadiapublishing.com

Search for your hometown history, your old stomping grounds, and even your favorite sports team.

Consistent with our mission to preserve history on a local level, this book was printed in South Carolina on American-made paper and manufactured entirely in the United States. Products carrying the accredited Forest Stewardship Council (FSC) label are printed on 100 percent FSC-certified paper.